BASICS

PROD

David Bramston

MW00581931

ava |**Academia**
the environment of learning

An AVA Book

Published by AVA Publishing SA
Rue des Fontenailles 16
Case Postale
1000 Lausanne 6
Switzerland
Tel: +41 786 005 109
Email: enquiries@avabooks.ch

Distributed by Thames & Hudson
(ex-North America)
181a High Holborn
London WC1V 7QX
United Kingdom
Tel: +44 20 7845 5000
Fax: +44 20 7845 5055
Email: sales@thameshudson.co.uk
www.thamesandhudson.com

Distributed in the USA and Canada by:
Ingram Publisher Services Inc
1 Ingram Blvd
La Vergne, TN 37086
USA
Telephone: +1 866 400 5351
Fax: +1 800 838 1149
Email: customer.service@ingrampublisherservices.com

English Language Support Office
AVA Publishing (UK) Ltd.
Tel: +44 1903 204 455
Email: enquiries@avabooks.ch

ISBN 978-2-940373-87-1 and 2-940373-87-6

10 9 8 7 6 5 4 3 2 1

Design by Malcolm Southward

Production by AVA Book Production Pte. Ltd.
Singapore
Tel: +65 6334 8173
Fax: +65 6259 9830
Email: production@avabooks.com.sg

Right: Where there's smoke, Maarten Baas, 2004.
Cover image: Porca Miseria! © Ingo Maurer, 2003.

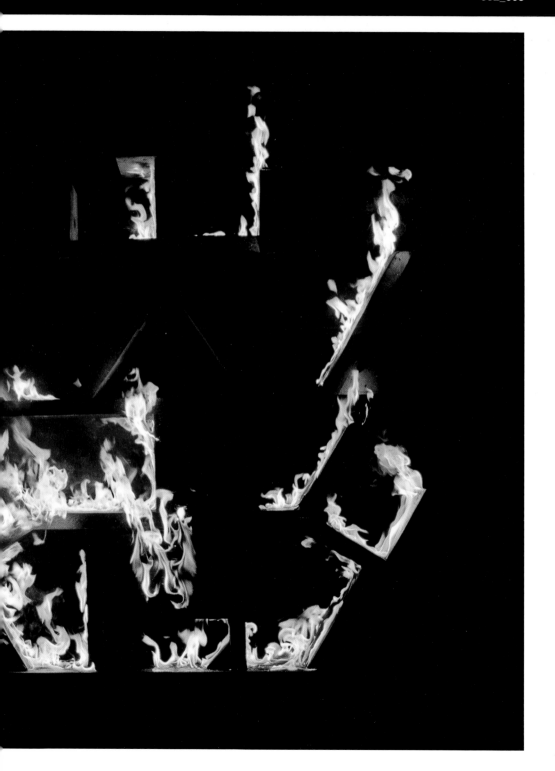

Contents

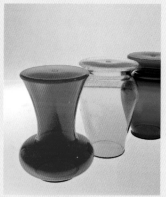

Material thoughts

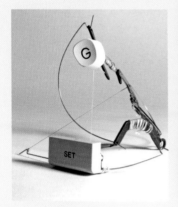
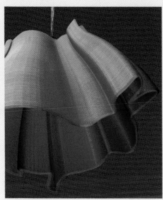

Contents

The aim of *Material Thoughts* is to inspire product design thinking with an investigation into the work of diverse practitioners, highlight the importance of interdisciplinary dialogue and to consider unfamiliar production methods and material usage. *Material Thoughts* therefore considers alternative approaches for materials by examining an array of different products, designers and artists. Material alone does not necessarily 'make' a design but it does have the capacity to elevate or enhance a proposal and demand attention.

The opportunity to explore materials and to discover their potential is constantly evolving. An inquisitive and curious mind is needed to ensure that materials continue to push creative boundaries while still remaining functional.

Liaison with other disciplines and cultures provides valuable insights into alternative applications of familiar materials; conjuring up an array of exciting possibilities. The barriers between the various creative disciplines are becoming blurred, with materials and manufacturing techniques previously restricted to a single specialist area being adopted and adapted by other groups.

A trend has emerged that allows for everything to be challenged with a 'why not?' and 'is it possible?' attitude. When materials are removed from familiar applications and techniques, and experimented on using different practices; exciting proposals can emerge and potential new markets can be identified. 'What happens when…?' is a question that should be considered continually and in different contexts. Investigative work with materials does not rely on the emergence of an unknown material, but rather on the way in which a material is regarded or categorised. Why are certain materials assumed to be suitable for specific tasks, when existing alternative practices have not been considered or introduced? Too many materials are confined to certain processes and should perhaps be revisited and appraised. Alternative and diverse applications for accustomed materials can often be refreshing and enlightening as they provide further opportunity to probe and inquire.

Is it possible to appreciate the unknown or the untested? Materials need to be subjected to different attitudes, approaches and feelings. They need to be thrown into the unknown and allowed to survive. They need to be allowed to find relationships with other materials, which perhaps have not been previously considered. Without testing and challenging conventional methods and materials it is unlikely that the exciting, unfamiliar or rewarding will emerge. Materials need to be held and understood, captivating and absorbing the imagination, before they are rejected or ignored.

Many innovative experiments with materials have gone unnoticed or have not been recognised for the important statements that they make. It is necessary to test conventional materials differently and to consider and evaluate the outcomes creatively.

It is important to understand how existing materials, techniques and approaches are typically employed in contemporary design. However, it is also necessary to explore emerging methods and the non-standard processes to which familiar materials are subjected.

Unconventional and non-economic methods of using materials often indicate a developing trend, and frequently evolve into viable propositions or influence future directions.

Applications such as fabrication, moulding and forming are too frequently attached only to specific materials with predictable outcomes. However, such methods can and are being applied to a variety of alternative materials, which appear to confront existing practices; often the consequences are refreshing, inspiring and rewarding. There isn't a dictum as to which materials should be subjected to what, and so constant evaluation and research is always necessary.

Combinations of materials, processes, and styles, which are usually not associated with each other, provide further opportunities to mix, match and explore. The material boundaries are being re-evaluated and challenged and elements such as scale, form, and reuse are being confronted; with accepted approaches threatened as the 'why not' approach tackles all.

The emergence of material libraries and resource centres provides increased opportunity to consider different applications of materials, introducing exciting possibilities and further potential.

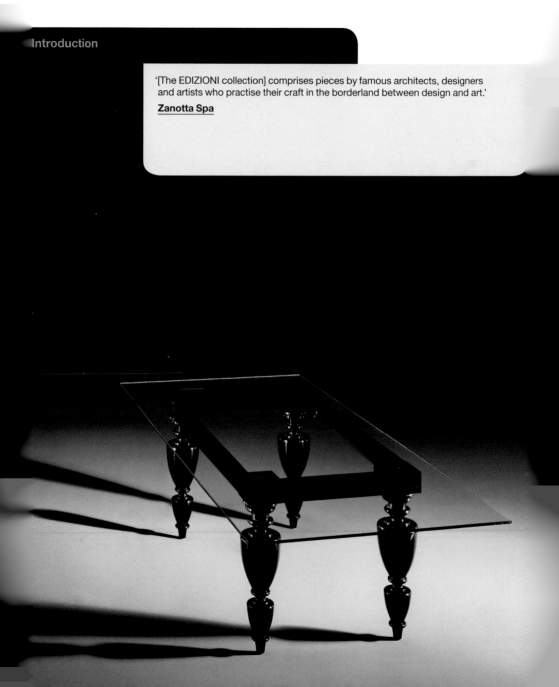

'[The EDIZIONI collection] comprises pieces by famous architects, designers and artists who practise their craft in the borderland between design and art.'

Zanotta Spa

Chapter 1
Impossible acts?
Impossible acts? concentrates on some innovative uses of the most familiar materials in product design through the work of some of the world's leading designers.

Chapter 2
Producers
The term 'producers' refers to manufacturers or individuals/ organisations that can actually realise a product from the initial design stage. Different manufacturing processes that are often utilised in production are explored. The materials investigated in Chapter 1 are referenced in the different processes.

Chapter 3
Visual stories
The exploration and effective use of a product's characteristics is investigated in *Visual stories*. The various issues are discussed and examples provided to show how a product could be effectively enhanced with appropriate finishes. Different case studies are referred to that relate to a broad range of materials.

Chapter 4
Experimental approaches
Experimental approaches concentrates on combinations of materials that have been utilised within product design and especially the unusual hybrid solutions. The area of 'mutant' materials is addressed and how materials can adopt unexpected characteristics. Reference to cross-discipline influences is also made.

Chapter 5
Instant acts
The production of models within the discipline of product design is a necessary process to communicate form, texture, soul and understanding. The impact of rapid prototyping is addressed and evaluated through various leading examples.

Chapter 6
Can it be done?
It is often difficult to know what material to use and how to access relevant information. Global material resource centres are discussed and how to engage with them.

A series of projects concludes the section; providing an opportunity to further explore and interact with materials.

Left
Dorian table (2002)
The Dorian table is part of the Zanotta Edizioni collection that focuses on 'precious furniture', combining craftsmanship, artistry and design.

Design
Dominique Mathieu,
for Zanotta

Photography
Marino Ramazzotti

Introduction > How to get the most out of this book

How to get the most out of this book

Material Thoughts aims to stimulate innovative approaches to the use of materials in product design. It explores interdisciplinary approaches to help identify alternative applications and directions for traditional materials and processes. It also examines the work of some the world's most adventurous designers to show what is possible with an imaginative interaction with a range of materials.

Boxed information
Provides supplementary content in the form of definitions, designer biographies and student exercises.

Simplicity and honesty

The purity and modesty of wood in its virginal state has a truth and integrity, that can be overlooked or not fully appreciated if not considered in context. Seemingly simple and innocent materials appear to have a naïve quality and a natural appeal that need to be embraced and respected for what they represent. Comprehension of an honest and untouched material, such as wood, requires a careful and thorough investigation over time. Although it may have been subjected to intense scrutiny many times before, it is often capable of revealing unexpected properties under different conditions.

Decades Chest of Drawers
The design benefits from the recycling of form in conjunction with the recycling of materials, enhancing the appeal of the item. The dual approach manages to evoke memories of previous times, styles and attitudes through the stories that are communicated by the individual components.

Design
Anna Irinarchos and Lisa Widén – Wis design

Below
Treasure Furniture: Yellow Dining Chair
The Treasure Furniture collection utilises waste MDF material from a furniture factory. The constraints of the waste directly influence the aesthetics of the furniture, creating an innocent appeal.

Design
Maarten Baas

Photography
Maarten van Houten

Right
Favela Chair
The design is inspired by the Favelas, the thickly populated slums in Brazil, which are innovatively constructed from found, rejected and broken materials. The Campana brothers' chair references the run-down innovation and curiosity of the shanty town approach. It is similarly constructed using small pieces of randomly sourced wood that are carefully considered and respectfully assembled despite the apparent limitations and constraints imposed. Edra, Spa, Italy, manufactures the Favela chair.

Design
Fernando and Humberto Campana

Fernando and Humberto Campana
Brazilian designers Fernando Campana (b. 1961) and Humberto Campana (b. 1953) use their ability to recognise the potential of simple materials to create a diverse range of sculptural products that combine integrity with a poetic aesthetic. The work of the Campana brothers includes the stainless steel Tatoo table (1999) and the glass Vaso Batuque (2000) both produced by Estúdio Campana, the Grendene fashion series in PVC produced by Grendene (2004–2005), and the Blow Up series for Alessi, Italy, in aluminium (2003).

Impossible acts?

Wood > Metal

Material thoughts

Section headings
Each chapter unit has a clear heading to allow readers to quickly locate an area of interest.

Body text
Supplies an in-depth discussion of the topics covered.

Chapter navigation
Highlights the current chapter unit and lists previous and following units.

Section sub-headings
Each section heading is divided into sub-headings to provide clear structure and ease of navigation.

Quotations
Help to place the topic being discussed into context by conveying the views and thoughts of designers and artists.

Glass and ceramic

Glass and ceramic are exciting materials that are being successfully explored and confronted. Although they both have a prestigious and respectable ancestry, contemporary developments continue to push and challenge the creative boundaries. Glass and ceramic should not be underestimated.

'Each shade is not particularly eye-catching but when grouped together in a unit they become harmonious and beautiful.'
Stuart Haygarth

Components and processes

Glass is essentially comprised of silica, soda/ potash and lime and adopts an interim viscous characteristic when subjected to intense temperatures. This viscosity provides interesting opportunities for exploitation and manipulation. The predominant approaches to the control of molten glass are blowing, casting, and pressing.

Blowing: The blowing of glass usually requires cullet or virgin glass to be heated sufficiently within a furnace to form a blob or parison. The molten material adheres to the end of a blow pipe and can be enlarged through small breaths of air. As the material swells the maker is able to influence the emerging shape. The forming of glass can also be achieved through inflating a parison within an identified mould and is similar to the principles of plastic blow moulding (see page 74).

Casting: Casting glass into a controlled form involves the generation of a mould and is a similar process to metal casting. A female sand mould, created using an existing artefact, can directly receive molten glass to faithfully replicate an intended form. An alternative option to sand is the use of a kiln-based mould that contains cullet. As the temperatures increase within the desired void the individual pieces melt, spread, and ultimately fuse to create the intended item.

Pressing: Pressing is a method that is often employed to form repeated items in a mould from molten glass. The process involves the controlled application of pressure to the viscous material, which is forced into the void to take up the form. The action requires careful monitoring to ensure that consistent and true outcomes are achieved.

Opposite
Shadow Light
Front produced the Shadow Light as part of FOUND collection. The designers, interested in the relationship of old and new, placed objects within the globes to create shadow decorations upon the glass surfaces.

Design
Front

Photography
Anna Lönnerstam

Above
Shadey Family
This chandelier utilises discarded and rejected glass lampshades to create a linear chandelier. The chandelier, as a collective community of found objects, manages to capture a beauty that the previously redundant pieces are perhaps unable to achieve alone.

Design
Stuart Haygarth

Cullet *n.* recycled broken or waste glass used in glass-making

Parison *n.* a rounded mass of glass formed by rolling the substance immediately after removal from the furnace

Impossible acts?

Plastic > **Glass and ceramic** > Paper

Images
Examples from contemporary designers and artists bring principles under discussion to life.

Captions
Provide contextual information about the products displayed.

Introduction > **How to get the most out of this book** > Impossible acts?

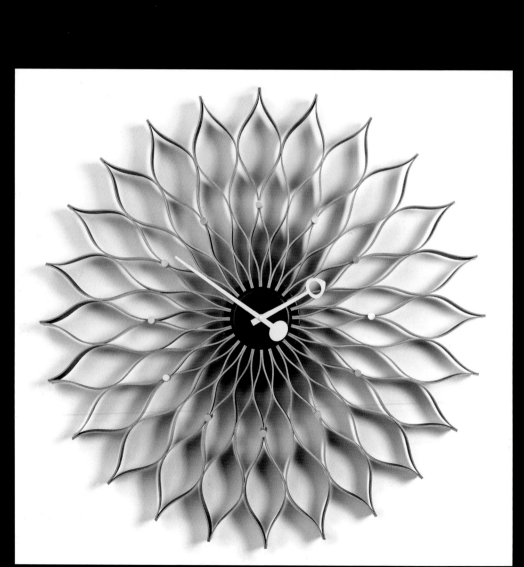

What material is really needed?

Although it is tempting to explore and consider the unfamiliar, the possibilities that are achievable with more accustomed materials can still captivate the imagination and remain a challenge.

Simple, honest and visceral uses of materials are effective and readily understood. The intuitive nature of physically working and engaging with straightforward and manageable materials provides the opportunity for a literal understanding of beauty, elegance and structure.

In contrast to an approach that can liberate an uncomplicated material through an actual connection, a material can be manipulated and subjected to rigorous controls to achieve the almost unachievable. These more radical approaches are not sacrilege or abhorrent but simply different, alternative objectives that push the frontiers of what can be achieved while retaining a comprehensive understanding of the material.

Materials and processes indigenous to product design are cross-pollinating with other disciplines as barriers descend and interrogation and exploration of alternative methods and procedures are examined.

Simple materials still have much that they can be exposed to and there are a variety of different references to be confronted regarding their application and handling.

The Sunflower Clock (1958)
The Sunflower Clock is constructed using birch plywood and the simple, delicate construction relays a sophistication that is often missing from more complicated products.

Design
George Nelson,
© Vitra Collections AG.
www.vitra.com

Photography
Andreas Sütterlin

Wood

The innocence of wood has been explored for generations using different methods and philosophies. This pristine and valuable resource that is so often shaped and formed into beautiful arrangements, can be reused and reinterpreted once the particular product it was originally crafted for has reached the end of its useful life.

Immediacy

A special relationship emerges between an individual and wood when it is worked using hand tools, as there is an opportunity to make instant decisions without sacrifice, something that cannot be so readily achieved or experienced through methods of mass-production. Although handmade is often synonymous with an intimate interaction it is perhaps more appropriate to consider handmade as meaning a procedure that has some form of user control, where the soul of the material can still be appreciated. The significance of odour, texture, colouration, and structure of wood can be instantly assessed through handmade methods, something that is not always possible through more remote means of manipulation.

There are several thousand different types of virgin wood and therefore the opportunity to experiment is substantial. The diversity of wood presents a multitude of potential properties that could be explored; it is the familiar, generally stable and more abundant woods such as oak, beech and ash that are often utilised.

Rare, difficult to access, unreliable or unstable woods are usually not selected for the generation of mass-produced products, but are experimented with and offer insights to alternative thinking. The main classifications of wood are generally softwood and hardwood. Softwood is essentially a material sourced from evergreen trees, while the familiar hardwood tends to come from deciduous trees, although exceptions do exist.

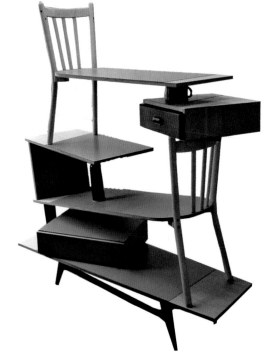

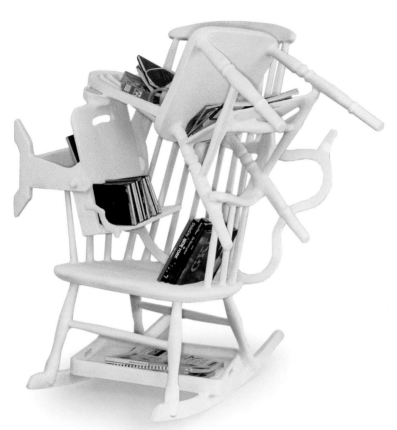

Left
**Hey, chair, be
a bookshelf!**
The sculptural bookshelf
involves the regeneration
of second hand products
in a design, which
recognises that items
can effectively adopt
a different role to that of
a former existence. The
rejected pieces viewed
differently and assembled
in an unfamiliar
configuration are able to
portray a different
message, and embrace
different functions.

Design
Maarten Baas
www.maartenbaas.com

Photography
Maarten van Houten

Opposite
Stapelkast
The various objects
including a drawer, chair
and table adopt an
original language when
their relationships are
reconfigured.

Stapel: group of items
on top of each other.

Kast: cupboard
or cabinet.

Design/photography
Tejo Remy and
René Veenhuizen

Maarten Baas
Maarten Baas
collaborates with
producer Bas den
Herder, with the Baas
& den Herder studio
in Eindhoven. The
partnership, since
2005, has resulted in
products, that
engage with creativity,
fun and originality.
www.maartenbaas.com

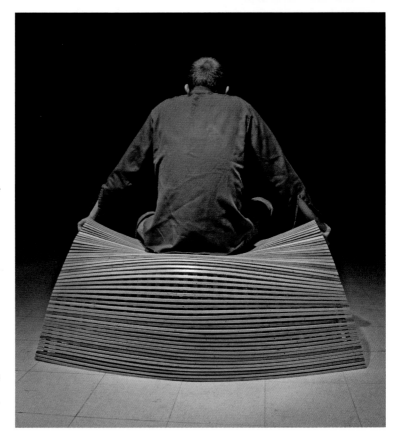

Bends, Ebb and Matthias Pliessnig's studio

Sculptural works such as Bends and Ebb represent a continual investigation of what is achievable with a seemingly static and unforgiving material. The elegant and graceful fluidity of Ebb can only be achieved with an investigative and exploring approach, an approach that respects a material but does not readily accept boundaries.

The studio of Matthias Pliessnig is a continual source of inspiration, where everything can be influential and ideas are allowed to evolve.

Design
Matthias Pliessnig

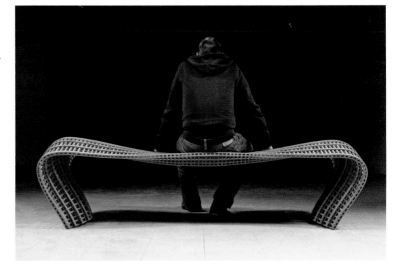

'Bends is a captured moment of human weight impacting form,
as if the piece was once pliable and retained the imprint of the sitter.'

Matthias Pliessnig

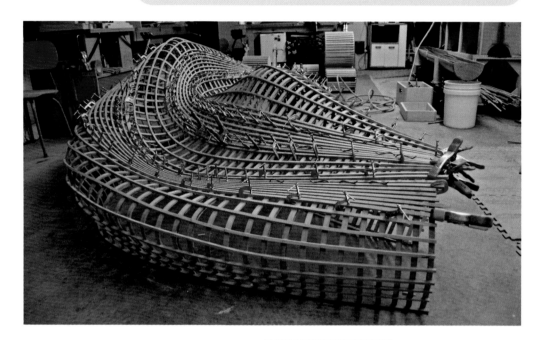

How to...
Ash, oak, and elm are
all woods that exhibit
good bending properties.
The fibres within the
woods become
temporarily supple when
heated with steam,
allowing flexibility.
Matthias Pliessnig takes
considerable care to
ensure that the wood
selected is sustainable
and appropriate. To
maximise the flexibility
of the wood the material
is initially air dried, a
practice that is popular
with hardwoods.

Simplicity and honesty

The purity and modesty of wood in its virginal
state has a truth and integrity that can be
overlooked or not fully appreciated if not
considered in context. Seemingly simple and
innocent materials appear to have a naïve
quality and a natural appeal that need to be
embraced and respected for what they
represent. Comprehension of an honest and
untouched material, such as wood, requires a
careful and thorough investigation over time.
Although it may have been subjected to
intense scrutiny many times before, it is often
capable of revealing unexpected properties
under different conditions.

**Decades Chest
of Drawers**
The design benefits from
the recycling of form
in conjunction with the
recycling of materials,
enhancing the appeal of
the item. The dual
approach manages to
evoke memories of
previous times, styles
and attitudes through the
stories that are
communicated by the
individual components.

Design
Anna Irinarchos and
Lisa Widén – WIS Design

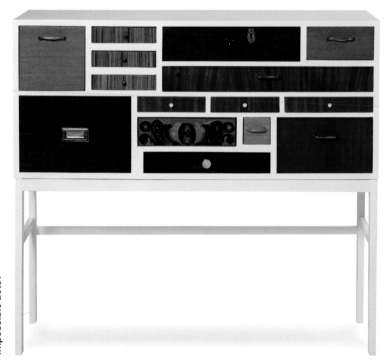

Below
Treasure Furniture:
Yellow Dining Chair
The Treasure Furniture collection utilises waste MDF material from a furniture factory. The constraints of the waste directly influence the aesthetics of the furniture, creating an innocent appeal.

Design
Maarten Baas

Photography
Maarten van Houten

Right
Favela Chair
The design is inspired by the Favelas, the thickly populated slums in Brazil, which are innovatively constructed from found, rejected and broken materials. The Campana brothers' chair references the run-down innovation and curiosity of the shanty town approach. It is similarly constructed using small pieces of randomly sourced wood that are carefully considered and respectfully assembled despite the apparent limitations and constraints imposed. Edra, Spa, Italy, manufactures the Favela chair.

Design
Fernando and Humberto Campana

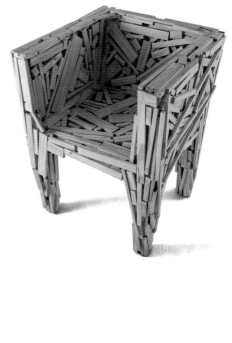

Fernando and Humberto Campana
Brazilian designers Fernando Campana (b.1961) and Humberto Campana (b.1953) use their ability to recognise the potential of simple materials to create a diverse range of sculptural products that combine integrity with a poetic aesthetic. The work of the Campana brothers includes the stainless steel Tatoo table (1999) and the glass Vaso Batuque (2000) both produced by Estúdio Campana, the Grendene fashion series in PVC produced by Grendene (2004–2005), and the Blow Up series for Alessi, Italy, in aluminium (2003).

Wood > Metal

'When love and skill work together expect a masterpiece.'
John Ruskin, art critic (1819–1900)

Complex and challenging

A close affinity with a material and the recognition of its susceptibility and vulnerability is usually acquired after considerable sensory exposure. The physical manipulation and mental investigation of a material arouses and provokes the imagination, often defying preconceived expectations, to develop an intimate understanding and appreciation of constraints within a particular context. Exploration of a material inevitably challenges boundaries and instigates a desire to discover exciting alternative practices that further question convention.

The metamorphosis of a material into something with enhanced distinction, elegance and refinement requires restraint as insensitive embellishment can often demean or degrade a transformation through a misunderstanding of purity, control and beauty.

The confrontation of psychological and tangible barriers and the exploration of a material from an alternative perspective using unfamiliar industrial processes does not eliminate the need for understanding and still requires an intimate knowledge and appreciation of previous investigations. The discovery of how a material might respond to processes more commonly associated with other disciplines or materials is intriguing and can provide opportunities for expanding previously uncharted frontiers.

Arts and Crafts Movement
The Arts and Crafts Movement opposed the utilisation of industrial methods of production, although there were some advocates within the group that recognised that limited machinery could perhaps be used to relieve the monotony of certain practices. The Arts and Crafts Movement was inspired by the writings of art critic John Ruskin.

Opposite
Shelf Space
Shelf Space combines elegance and precision; craft and machine.

Design/photography
Paul Loebach

Impossible acts?

'The result of an experimental collaboration with an aerospace machinery manufacturer, this shelf's fluid form pushes the limits of wood engineering and advanced machining technology ... to invoke a dialogue between technologically driven innovation and the continuity of historic reference.'

Paul Loebach, 2008

Industrial processes and traditional practices are becoming more aligned and sympathetic with mass-production, embracing the one-off aesthetic with dignity and respect. The appeal of the personal touch to the mass-market is being recognised, and concerns that insensitive, industrial practices eradicate the soul and understanding of a material are being rejected.

The acquired knowledge of generations is not being challenged or compromised by machine; rather it has the opportunity to be developed and confront the boundaries of creativity with empathy and unrelenting sophistication at a fundamental and unparalleled level.

A material should be challenged through experimentation, with alternative methods of manipulation being summoned to help reveal previously unrecognised characteristics with appeal and grace.

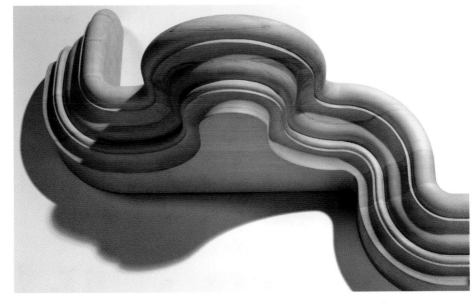

Wood > Metal

'We work in a similar way [to how] the haute couture fashion world works. Our studio will take the largest amount of artistic freedom to express valuable concepts, fantastic stories in projects that know no limitations....'

Demakersvan, 2008

Sophistication

Sophistication does not simply refer to a visual language of grace and beauty, where sweeping lines and emotive and uncluttered thoughts are expressed; nor does it rely on the quality of a material utilised in an object. An expression of sophistication can be achieved through an appreciation of form, material potential, or both. A sophisticated outcome can be achieved through ingenious labour-intensive methods with limited tools at the maker's disposal and does not always require extensive resources; it is the understanding and experience of doing something. Although an outcome may appear uncomplicated, it is often the skill of the worker that has managed to control a material to create such an impression. An ability to emulate styles and cultural trends through innovative approaches can be achieved by the marriage of traditional references and innovative ideas. For example, a single aspect of perceived quality and finish associated with prestigious or antique products can be introduced to very ordinary and simple materials to engender a desired attribute.

Everyone has some form of inherent understanding of what sophistication represents, through their own experiences and associations. In order for a product to have an air of sophistication it needs to be able to make metaphorical and literal connections. There needs to be an appreciation of what sophistication represents and awareness, appreciation and respect for similar expressions. Sophistication does not need to be directly interpreted or copied – to do so would probably lessen the appeal – it should demonstrate an intuitive understanding of culture.

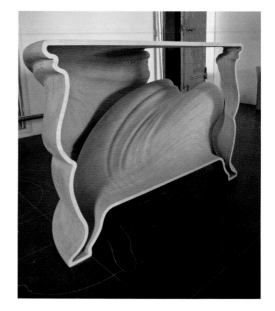

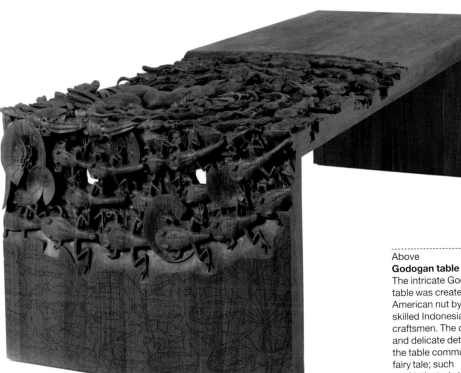

Above
Godogan table
The intricate Godogan table was created in American nut by extremely skilled Indonesian craftsmen. The complex and delicate detailing of the table communicates a fairy tale; such sophisticated skills are becoming limited as more efficient production methods are adopted.

Design
Niels van Eijk and Miriam van der Lubbe for Droog

Opposite
Cinderella Table
The elegant form of the Demakersvan Cinderella Table merges historical referencing with contemporary technology. The plywood design is part of the permanent collection at the Museum of Modern Art in New York.

Design
Jeroen Verhoeven at Demakersvan

Photography
Hans van der Mars

Wood grain
Natural woods all have a tendency to warp, twist and split if they are not carefully managed and appropriately seasoned. The direction of the grain within the wood needs to be taken into consideration as any shrinkage that occurs could be detrimental to the end product. Manufactured plywood is composed of layers of wood where the grain alternates and therefore reduces the likelihood of shrinkage.

Captivating creativity

The search for originality and innovation does not always require discovering the obscure as far as materials are concerned, but does require an understanding of the manner in which they are regarded and utilised. Distinct and unadorned materials are everywhere in a natural or synthetic state and can always be explored further to ascertain an original context without the need to embark on complicated paths.

Existing materials can offer much scope for reuse and it is not always necessary to look too far for ideas and inspiration. The portrayal of an item produced using a particular material can be taken out of context and presented independently of previous encounters. Personalisation and user-modification of products often involves the incorporation of found items; items that have sentimental value or appeal that cannot be recognised in an item in its mundane or natural state. The aim to be unique and create an authentic, original and intimate product, a hybrid with visual appeal and personal attachment, is becoming ever more significant. Found and old objects, coupled with the new, can create an unrivalled inspirational marriage.

The juxtaposition of old and new in an original configuration can provide an appealing and refreshing visual dialogue and offers the opportunity to use contrasting materials and processes in an eclectic harmony.

Many designers and artists are using found objects in their work either directly as a presentable artefact or during the development of an idea to prompt thinking, direction and explore the product narrative.

Unfortunately it is not uncommon for perfectly good products to be discarded because of a change of fashion or perhaps because a single component has been damaged. A component, which could readily be fixed, or utilised differently, is all too often rejected completely. These discarded components are often the inspiration for emerging ideas and directions in alternative cultures or markets.

Utilising existing components, being able to modify and respond positively to minor faults, or taking control of an item and empowering the user to personalise it is evolving into a necessary and required course of action. Many innovative designers have been experimenting with these techniques and achieving truly inspirational and exhilarating outcomes.

Fibreboards

Fibreboards are usually produced by the controlled pressing of macerated wood fibres with resin at identified temperatures. Although different density fibreboards can be produced, medium-density fibreboard is undoubtedly the most common. In addition to fibreboards, particle boards and plywoods provide an interesting alternative to natural woods.

'My intention is to investigate the potential for creating useful new designs by blending together stylistic or structural elements of existing chair types.'

Martino Gamper, 100 chairs in 100 days (2007)

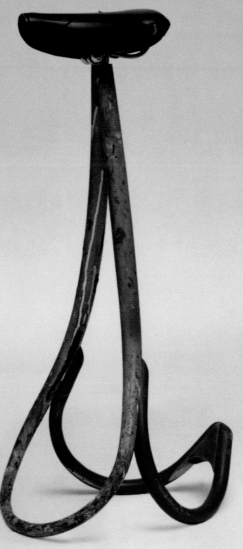

Achille's Bicicletta (2006)
Achille's Bicicletta is reminiscent of the 1957 Sella Bicycle stool by Achille Castiglioni (1918–2002). It is a tribute, by Martino Gamper, to the work of the influential Italian designer who found much inspiration in the ordinary and found objects.

Design
Martino Gamper
© Åbäke
© Martino Gamper

Martino Gamper
An Italian background of cabinet making, sculpture and product design informs the direction of Martino Gamper's work and enquiry. Interested in the language of products, their story and social meaning, Martino Gamper collected old and broken pieces of furniture and other curiosities to assemble a distinctive and inspirational range of furniture during his '100 chairs in 100 days' project.

Martino Gamper has exhibited work at many leading design galleries.

Wood > Metal

Metal

The attraction of metal is its amenability, strength and capacity to reveal an inner beauty, and traditional processes available to manipulate it continue to provide abundant opportunities for innovative designs. In addition , with the development of new processes, it is still being challenged to perform in unaccustomed and unfamiliar ways to produce compelling results.

Processes

There are many different processes that can be employed to work metal and although the material has been sculpted for generations, exciting possibilities continue to emerge. A burgeoning understanding of contemporary approaches suitably complements traditional methods such as casting, forging, and pressing.

Casting: Moulds capable of receiving molten material can be used to form metal products. Sand, plaster, wax, or plastic are often used for temporary, one-off or complicated moulds as they are usually destroyed during the forming process. Durable moulds are used for repeated or mass-production use. Although other materials might offer alternative solutions or advantages to casting, metal retains an innate attraction for certain applications.

Forging: The forging process involves heating material to a specific temperature and subsequently applying a direct force. The benefit of forging metal is that the material retains its strength, something which is often reduced through more invasive methods. One-off products can be achieved through forging with an anvil and hammer, however industrial presses that are capable of exerting targeted pressures are normally used for mass-production. Forged products often require some form of post-production work in order to attain the required finish.

Pressing: The process usually involves the use of industrial presses to transform a flat, preformed sheet of material (usually steel) into the desired form. The deformation executed by the press tool ensures that the material is unable to regain its initial composition.

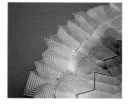

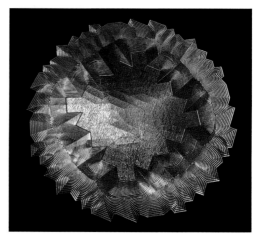

Impossible acts?

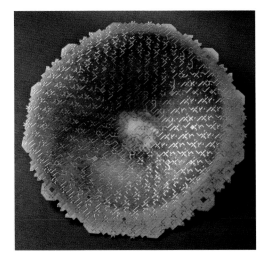

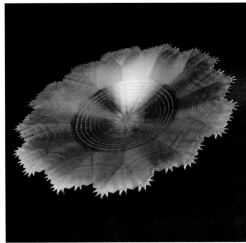

**Star Tessellation series
and Flat Stardish**
This attractive series
communicates the
incredible detail, versatility
and morphology that
can be achieved through
imaginative cnc milling
of aluminium.

Design
Drummond Masterton

CNC milling
Computer Numerical
Control (CNC) milling
refers to the monitored
and gradual removal of
material using a computer
guided machine tool.
Detailed and formalised
decisions are made by
the maker in advance of
the automated and often
independent process.
The subsequent and
intrinsic communication
between the computer
and the cutting interface
ensures that a physical,
often intricate and
involved facsimile is
achieved. The process
can be accurately and
constantly repeated.

Wood > **Metal** > Plastic

Unconventional approaches

It is difficult to choose between conflicting approaches and the subjective opinions of critics, but it is still necessary to look and listen and appreciate the attitudes of others. The activity of analogous referencing to assist in the generation of new ideas can also be used to consider processes and the way a material might be manipulated in an alternative context.

It is important to venture into the unknown and be prepared to take risks that 'dare to be different'. If it is not possible to expand horizons by physically integrating with an unfamiliar discipline (such as fashion or architecture) it can still be achieved through other means.

Reviewing a journal associated to a different area, with an alternative perspective, can expand creative boundaries and plant seeds for the interpretation of how a material might be worked.

For example, a particular production method usually associated with fashion could be taken out of context and transposed to a new set of materials. The knitting of metals, stitching of plastics, or the welding of wood all portray elements of cross-discipline fertilisation.

Analogous *adj.*
Comparable in certain respects

Homologous *adj.*
Having the same relation, relative position, or structure

How to...
Analogous referencing requires observation, identification, and understanding of how similar problems are approached in seemingly unrelated areas. Recognising how materials are utilised, respected and worked elsewhere can provide the opportunity to transpose ideas and thoughts to a specific activity.

Innovative

It would be arrogant to think that other disciplines do not have anything to offer and ignorant not to search for cultural exchanges. A refreshing walk through the environment of an unfamiliar discipline will almost certainly provide much valuable inspiration. Inspiration that, if developed, will permit the fruition of innovative approaches. 'What if?' cultures can be developed through an exposure to the unfamiliar. Cultural merging and the shadowing of peers in different subject environments prevent a sterile, creative vacuum from forming and promote dialogue. A mindset of research, investigation, asking why, and embracing opportunities to try out things without fear of making mistakes exposes innovative directions and outcomes.

A stubborn allegiance to a particular process can be problematic, but a continual search for ideas and the infiltrating of different practices to awaken a potential will remove such boundaries. The marriage of identities, language and respect breeds a positive relationship and cohesiveness that ultimately engenders an unconventional approach that has a power to excite and fascinate and leads to the question, 'why not?'.

Chinese Stools – made in China, copied by Dutch (2007)
Designer Wieki Somers observed the intriguing variety of modifications and ongoing repairs that Beijing street workers made to their seats. The seating mutations and alterations represented an ongoing commentary, a story that Wieki Somers captured in aluminium and lacquer. Although the inspirational pieces were lost in the production process the aesthetic narrative remains.

Design
Wieki Somers

Photography
Pien Spijkers

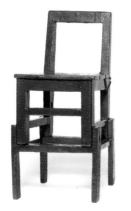
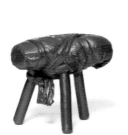
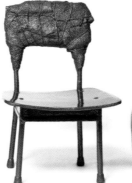

Wood > Metal > Plastic

Beautiful strength

The beauty and versatility of metal is something that is evidenced in a broad spectrum of applications, styles and movements. The delicate and decorative use of metal during the art nouveau and subsequent art deco periods are in contrast to the formal and controlled approaches of the Bauhaus style, where ornamentation and superfluous considerations were regarded as unnecessary and even obscene. Innocent and seemingly unsophisticated approaches to the use of metal, such as folding, pressing, and bending can achieve beautiful and strong results if the potential of the material is recognised. Such seemingly fundamental activities can still push the creative boundaries.

The craftsmanship of working metal is particularly evident in the approaches undertaken by coachbuilders and fabricators who are able to manoeuvre and configure the material to extract not only a desired physical virtue but also identify a form that enhances the potency of the material. Compound curves, corrugations and folds provide an opportunity to explore capabilities through investigation and understanding.

Industrial designers such as Raymond Loewy (1893–1986) managed to manipulate and control metal in designs that exude power and strength within beautiful and sensual forms. The cast and forged metals that constituted so many components of the magnificent bridges and locomotives of the industrial age, and symbolised strength and prosperity, are perhaps the ultimate statements of beautiful strength. Architectural reclaim yards and sculpture parks provide an opportunity to view a broad range of items that have been produced honestly and simply using these casting or forging processes.

Understanding the balance between strength and beauty is something that is often overlooked, resulting in the natural appeal of the material being disfigured by unnecessary ornamentation. Decoration is often not needed to enhance metal as, if it has been fully understood and interacted with properly, the completed item is usually capable of sensory stimulation without the need for adornment.

Coach-built *adj.*
(of a vehicle) having specially or individually built bodywork

Metal can be exploited through numerous different processes and is capable of responding to a multitude of very different demands and requirements. Although experimentation provides the opportunity to continually discover original methods of working metal, which should be encouraged, along with the cross-pollination of approaches, the fundamental and basic processes that have been used for generations should remain a foundation during periods of curiosity.

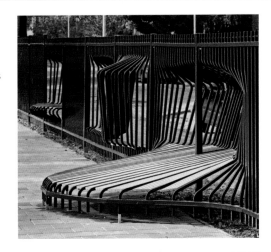

Below
Baghdad (2005)
Baghdad is part of the Edra special collection and is constructed using industrial steel contours, which collectively form a plan of the capital.

Design
Ezri Tarazi

Above
Ontmoetingsplekhek (Playground fence) (2005)
Designed for the primary school Het Noorderlicht in Dordrecht. The innovative and simple approach to the fence creates a meeting and talking place that can be utilised by users on both sides.

Design
Tejo Remy and René Veenhuizen

Photography
Tejo Remy and René Veenhuizen/Herbert Wiggerman

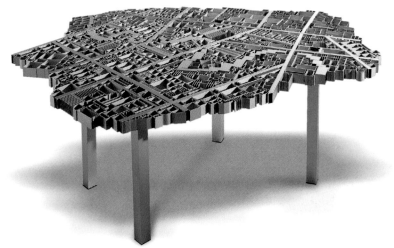

Wood > **Metal** > Plastic

Plastic

Although plastic might be considered to be a somewhat recent arrival its presence and impact on product design should not be underestimated. Plastic is everywhere; able to assume a multitude of functions and frequently displacing more traditional materials.

Polymers

Plastic can exude multiple properties that are prepared to challenge, and improve, on a conventional genre of materials. Because the material make-up can be manipulated the range of possibilities is almost limitless, and is only constrained by the imagination of the individual. Plastic can readily adopt complicated morphologies, can demonstrate qualities such as chemical and impact resistance, and can also be transparent.

The diverse range of polymer chains that can be generated and configured through the linking of monomers ensures that necessary characteristics can be available within a raw material. An informed and holistic approach to polymer selection for a particular purpose can be beneficial at numerous practical and aesthetic levels, including a reduction in post-production processes.

Below
Zulu War Bowl
The distinctive preformed Zulu plastic soldier figures are used simply but effectively to form the delicate and intricate appearance of the bowl. The manner in which the bowls are produced ensures that each piece has an individual charm and appeal. The battles of the English Civil War and Waterloo are also represented.

Design
Dominic Wilcox for Thorsten van Elten

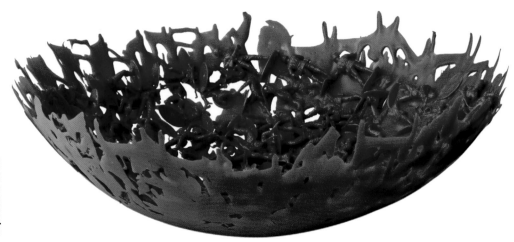

Impossible acts?

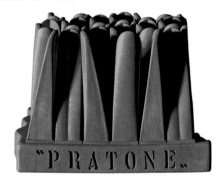

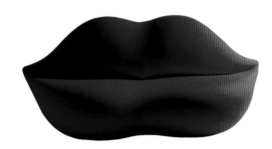

Above
Pratone (1968)
The large grass, manufactured by Gufram and part of the 'i multipli' collection, provides an artificial lawn or meadow for people to lie down and relax on. 'Pratone' grass encourages interaction and questions conventional approaches, an attribute that made the design an iconic symbol.

Design
Giorgio Ceretti, Pietro Derossi, and Riccardo Rosso

Above
Pink Lady (2008)
The Gufram 'Pink Lady' sofa inspired by the Gufram 'i multipli' red lipstick sofa 'Bocca' designed by Studio 65 (1970). The designs reflect popular culture, combining sculpture with functional fun.

Design/photography
Gufram

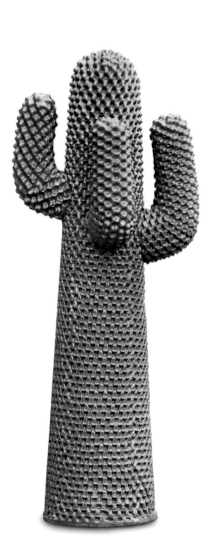

Left
Cactus (1972)
The Gufram 'Cactus' coat-stand is produced in expanded polyurethane. The 'Cactus' has been an iconic feature of Italian design since the 1970s.

Design
Guido Drocco and Franco Mello

Photography
Gufram

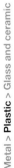

Metal > **Plastic** > Glass and ceramic

Fun

If there is any material that could be categorised as being fun, it is plastic, with its numerous feel good associations and almost playful adaptability. A material that is able to mimic more sought-after materials, plastic has enjoyed much success in a diverse range of markets due to its flexibility and affordability. The metamorphosis of plastic from the bland and mundane to something capable of exciting and enthralling an audience is perhaps unique in the history of product design. Plastic has been utilised to magnificent effect, but has also been allowed to succumb to trivial exposure and experimentation simply because it can be done. Throwaway items and trinkets, with no discernible function, in any shape or form, are possible, as are more sophisticated and respected items that appear to demand a similar status to more esteemed and valued materials. The inquisitive mind that drives investigation with plastic is limited only by the creativity of the designer and opportunities to engage with the material using different protocols; alternative methods and thinking should be considered in an attempt to elevate the general perception and regard for this marvellous material.

Plastic is able to provide an almost superficial feel good factor, offering something that can be absorbed and enjoyed without real commitment.
A fun, responsible and ingenious approach to the use of plastics through lateral thinking and experimentation is becoming increasingly evident, as can be seen in Sebastien Wierinck's Temporary furniture installation (shown opposite).

Polyethylene (PE), often called polythene, is an incredibly common and diverse plastic. The applications for polyethylene vary between those that are classified as being Low Density Polyethylene (LDPE), which are generally tough and flexible, and the harder and stiffer High Density Polyethylene (HDPE). Polyethylene can be soft, brittle, strong, tough and smooth.

Other common types of plastic are:
Polystyrene (PS)
Polyvinyl chloride (PVC)
Polypropylene (PP)
Polyoxymethylene (POM)
Polytetrafluoroethylene (PTFE)
Polyamide (PA)
Polyurethane (PU)

**Temporary furniture installation
Sebastien Wierinck –
OnSite Studio (2007)**
The furniture is constructed using Polyethylene (PE) flexible tubes, and a stainless steel structure. The curvaceous and organic seating system utilises the industrial tubing in an unconventional, creative and dramatic fashion.

Design
© Sebastien Wierinck

Co-production of the installation by Gallery Into ArtandFurniture. Region PACA, Association de Designeurs.

Photography
Frank Seehausen

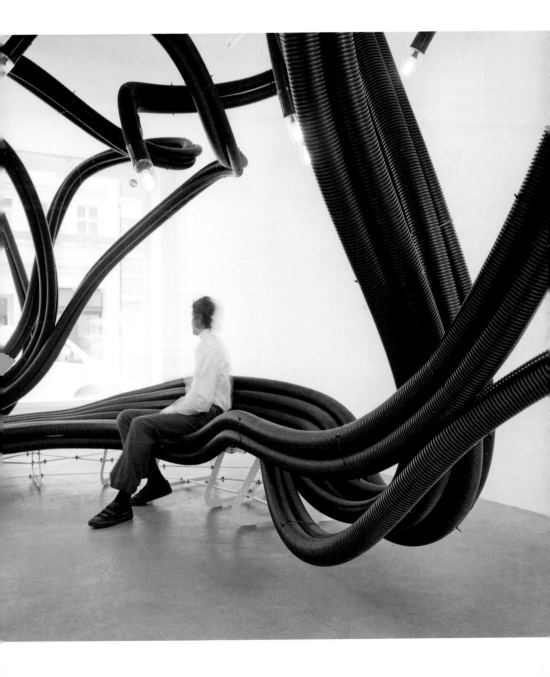

Alluring

An appealing and alluring feature of plastic is its innate adaptability, through its various permutations, to fulfil the diverse and seemingly impossible demands that are made of it at pre- and post-production stages. The flexibility of the material is enticing and the many mutations available have seen it forge an acceptance in an assorted range of atypical fields. The various methods of controlling, configuring, fabricating and sculpting plastic (often transposed, influenced or absorbed from an assimilation of many encounters and observations) enables unlimited exploration, a merging of alternative strategies and a tempting, sometimes teasing incentive to experiment.

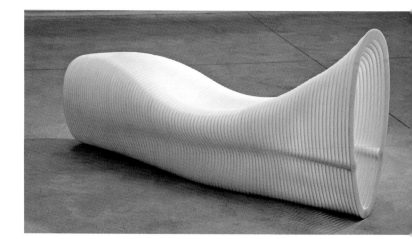

Slice Chaise
The organic, fluid
form of the chaise-longue
is appealing both
emotionally and
ergonomically and
manages to successfully
challenge conventional
perceptions at many
different levels.
Construction of the
elegant and graceful piece
is achieved through
careful manipulation and
understanding of acrylic.

Design/photography
Mathias Bengtsson

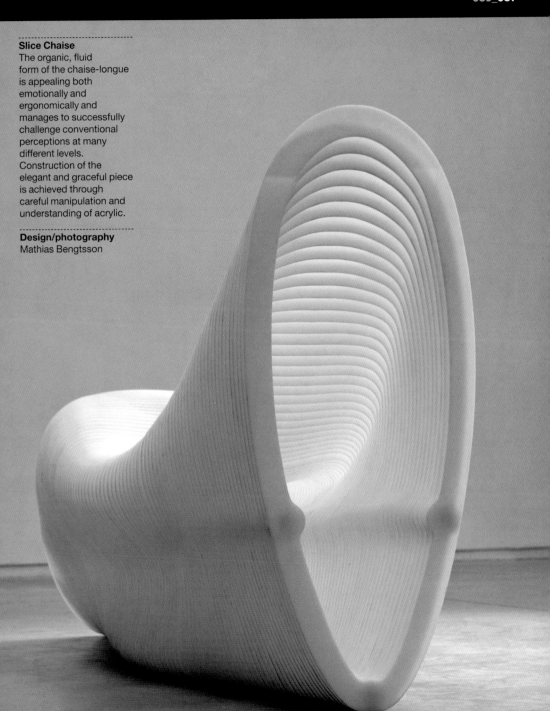

Nostalgia and recall

Experiments and practices developed by creative predecessors including artists, designers and craftsmen should not be overlooked or forgotten as they have certainly influenced current direction and can undoubtedly inspire contemporary thinking. An appreciation of previous approaches and solutions provides a valuable foundation for development and it is just as important to learn from mistakes as it is to embrace and acknowledge achievements. If something can be recalled it is possible that it made a lasting impression because it offered something innovative or introduced an original experience, but not all memories are made through positive associations. A review or critical appraisal of bygone challenges should delve deep to avoid mental baggage and embellishment in order to recognise positives that might assist or inspire contemporary products. Proponents of the innovative perhaps prefer to ignore the past, but ideas and approaches often have a cyclical nature and avoidance or ignorance of previous times can be detrimental.

A diverse array of items in museums, galleries and private collections, that were subjected to different constraints, cultures and conditions, provide valuable insight into the popular styles and periods of the past. The stories, messages and social conscience that these products can communicate should be encountered and experienced to prompt thoughts and feelings.

An understanding of historical references and influences beckons the recall of memories; experiences that might otherwise be lost. It is not a facsimile of former ideas that is required but an ability to reflect through observation and listening and to place imagination in context.

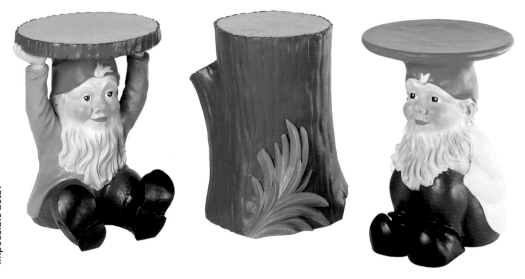

A relentless compulsion to question and probe the exhaustive possibilities of plastic can be a rewarding experience. The ardent investigator needs an adaptive capacity to look beyond fundamental requirements and envisage the full potential of a material so as to transform something ordinary into a desirable object that appeals on different levels and stimulates the senses. Exploiting different visual languages to realise something that respects constraints without diminishing creativity should be addictive and can reveal tempting new ideas. However, when plastic is not challenged or required to perform originally the outcome can often appear mundane, familiar and uninspiring.

Opposite
The Gnomes Attila & Napoleon (stool/table) (1999)
The painted, thermoplastic gnomes manage to combine functionality with fun and are able to communicate a variety of practical, emotive, and aesthetic messages. The contemporary approach recognises previous languages related to popular culture.

Design
Philippe Starck for Kartell

Below
Soft washbowl
The soft polyurethane washbowl successfully explores and understands the product language and accommodates the user by being flexible and sensitive to the touch.

Design
Hella Jongerius for Droog

Photography
Robaard/Theuwkens. Image concept by Mario Kranenborg

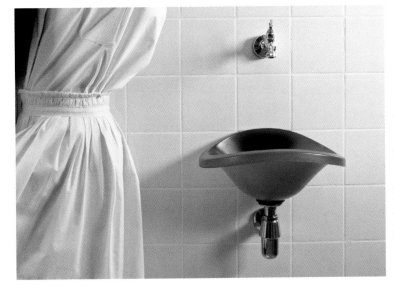

Metal > **Plastic** > Glass and ceramic

Passion

There are so many different genres and grades of plastic that it is often possible to find an equal number of positive and negative attributes within the range of a single material. For example, familiar variants of polystyrene include high-impact polystyrene (used in yoghurt pots, vending-machine cups, toilet seats etc.), expanded polystyrene (used in protective packaging) and Acrylonitrile Butadiene Styrene or ABS (used in telephone handsets, safety helmets etc.). The differences are obvious and so too are the characteristics, despite all being classified as polystyrene.

The selection of a suitable material for a specific task can be daunting and confusing, especially when disparate types of plastic portray no discernible differences. In addition to the extensive range of plastics that are at the disposal of the designer, moulding preferences, the individual characteristics required and the inevitable cost implications further complicate choice. Understanding the difference between what is desired and what is required can be difficult but analogous referencing can assist in material selection. Many similar products are made in alternative materials due to the different conditions where they will eventually be used.

The producers of the raw materials are constantly developing and discovering different types of plastic to innovate markets while meeting existing supply demands. Liaison with global libraries provides the opportunity to consider a broad spectrum of plastic materials and the identification of the most suitable for a particular task.

Seam Chair
The Seam Chair is part of the Dry Tech 3 project by Droog.

Design
Chris Kabel for Droog

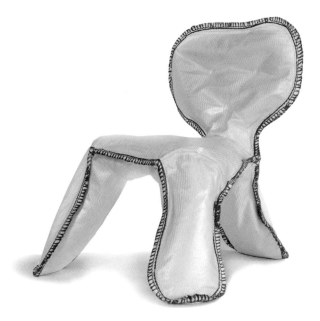

Impossible acts?

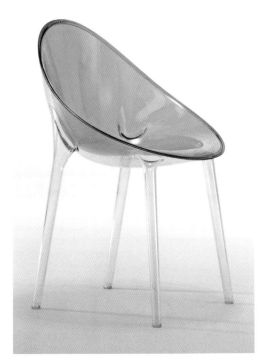

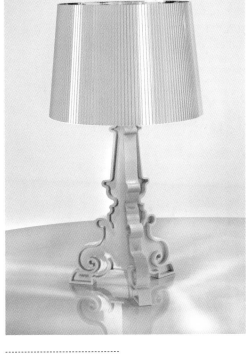

Mr Impossible chair
The Mr Impossible chair is produced using transparent and batch-dyed polycarbonate that conforms to the high standards associated with Kartell and their designers.

Design
Philippe Starck for Kartell

Bourgie lamp
The baroque-inspired Bourgie lamp, produced in either transparent or dye-batched polycarbonate, manages to contrast contemporary manufacturing with classical style.

Design
Ferruccio Laviani
for Kartell

Metal > **Plastic** > Glass and ceramic

Glass and ceramic are exciting materials that are being successfully explored and confronted. Although they both have a prestigious and respectable ancestry, contemporary developments continue to push and challenge the creative boundaries. Glass and ceramic should not be underestimated.

Components and processes

Glass is essentially comprised of silica, soda/potash and lime and adopts an interim viscous characteristic when subjected to intense temperatures. This viscosity provides interesting opportunities for exploitation and manipulation. The predominant approaches to the control of molten glass are blowing, casting, and pressing.

Blowing: The blowing of glass usually requires cullet or virgin glass to be heated sufficiently within a furnace to form a blob or parison. The molten material adheres to the end of a blow pipe and can be enlarged through small breaths of air. As the material swells the maker is able to influence the emerging shape. The forming of glass can also be achieved through inflating a parison within an identified mould and is similar to the principles of plastic blow moulding (see page 74).

Casting: Casting glass into a controlled form involves the generation of a mould and is a similar process to metal casting. A female sand mould, created using an existing artefact, can directly receive molten glass to faithfully replicate an intended form. An alternative option to sand is the use of a kiln-based mould that contains cullet. As the temperatures increase within the desired void the individual pieces melt, spread, and ultimately fuse to create the intended item.

Pressing: Pressing is a method that is often employed to form repeated items in a mould from molten glass. The process involves the controlled application of pressure to the viscous material, which is forced into the void to take up the form. The action requires careful monitoring to ensure that consistent and true outcomes are achieved.

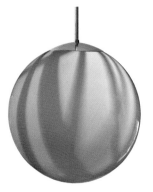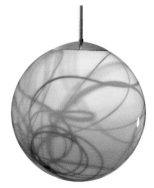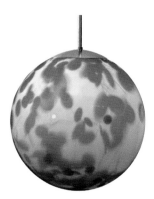

Impossible acts?

'Each shade is not particularly eye-catching but when grouped together in a unit they become harmonious and beautiful.'

Stuart Haygarth

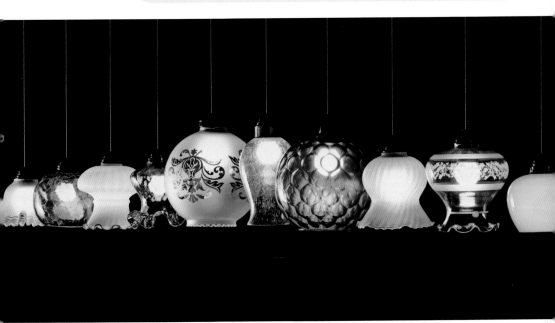

Cullet *n*. recycled broken or waste glass used in glass-making

Parison *n*. a rounded mass of glass formed by rolling the substance immediately after removal from the furnace

Opposite
Shadow Light
Front produced the Shadow Light as part of FOUND collection. The designers, interested in the relationship of old and new, placed objects within the globes to create shadow decorations upon the glass surfaces.

Design
Front

Photography
Anna Lönnerstam

Above
Shadey Family
This chandelier utilises discarded and rejected glass lampshades to create a linear chandelier. The chandelier, as a collective community of found objects, manages to capture a beauty that the previously redundant pieces are perhaps unable to achieve alone.

Design
Stuart Haygarth

Characters

The subtle manipulation of a form can have a radical impact on the manner in which a product is received or perceived. In cases where it is not possible or not desired to adjust the physical form, the character of a product can be modified through a simple variation in presentation.

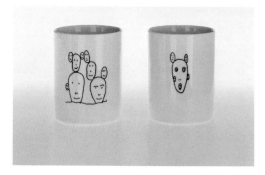

Alessi
In 1921 Giovanni Alessi Anghini founded a metalwork business in Omegna, Italy, a company that upheld standards and became a recognised and respected 'design factory' for original thinking.

The metal factory, Alessi, embraced a professional craft philosophy, initially producing kitchen related items, but appropriately diversifying during subsequent generations to explore different markets and materials.

The company sought the external expertise of the design 'maestros' Achille Castiglioni, Ettore Sottsass, Richard Sapper and Alessandro Mendini who were collectively instrumental in the creative development of Alessi. A combination of astute design and business acumen has resulted in Alessi successfully retaining its original crafted ethos while embracing a mass production culture.

Top
Genetic Tales (1998)
These white porcelain mugs have an illustrated 'cactus' pattern on them, while the flower vases produced as part of the same series displayed 'small faces'. The vases were a limited edition of 99,999 one-off pieces, each with a unique, numbered face illustration.

Design
Andrea Branzi for Alessi

Above
100% Make-Up (1989–1992)
Alessandro Mendini's distinctive porcelain vase was produced ten thousand times and decorated by 100 leading influential figures in art, design and associated disciplines. The individual 'decorators' had their design applied to 100 vases. The outcomes were as diverse and intriguing as the individual characters that created them.

Design
Alessandro Mendini

Inspirational

Inspiration is omnipresent, but it is important to understand what is being observed and to develop a capacity to translate sensory impulses into tangible references. 'What does it mean?', should be a constantly present thought and something that is considered no matter what the circumstance. It is possible to access inspirational triggers that are immediately presented, but it is preferable to encounter different experiences and develop a hunger for more. Everything can, and should be, questioned in an attempt to develop new opportunities.

Egg Vase (1997)
Placing hard-boiled eggs inside a condom produces this unusual organic form during the creation of the porcelain Egg Vase in the kiln.

Design
Marcel Wanders in a project with Droog Design and Rosenthal

Photography
Moooi

Lustres
Lustres are iridescent coatings that are created by a secondary firing of glazed items following the application of a thin surface covering of reduced metal. The additional firing fixes the metal to the glazed surface and creates the lustre.

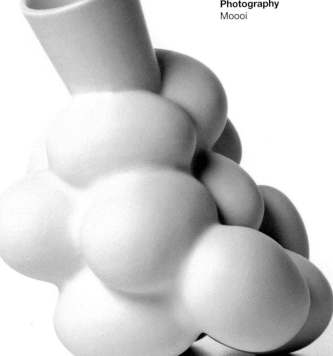

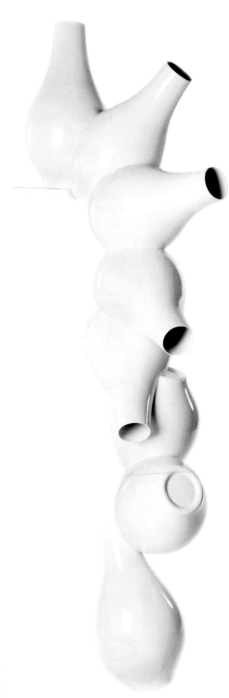

Left
Falling Vase
The 'falling vase' designed by Swedish designers Front is part of their 'design by...' series that embraces an external influence in the product. The dynamism of a falling vase is captured within a single object in 'design by motion'.

Design
Front

Photography
Anna Lönnerstam

Below
Broken White
'A crack in a ceramic object is usually perceived as error. Here the crack line is made useful by deforming and using it to draw the decoration. So the material itself makes the decoration, paint is redundant.' Simon Heijdens

Design
Simon Heijdens

Imperfection

When a product becomes tarnished or broken, it is often rejected and ignored, but in certain circumstances it is possible for such defects or impairments to be deliberately incorporated into a design, elevating what might normally be perceived as a negative attribute into something beautiful.

The ability to challenge accepted perceptions of a material in order to propel thinking towards possible ambiguity and uncertainty can often release a plethora of pure ideas that are instantaneously endorsed.

The use or production of broken and salvaged ceramic components can be an inspirational catalyst culminating in outcomes that are synonymous with abstract art, in that they can be interpreted differently depending on the individual observer. The often chaotic impression of work that introduces a blemished or seemingly ruined element does not lessen the overall experience if the piece is appropriately composed, constructed, and controlled.

A single component of a design can often make the difference between success and failure. Carefully addressing individual areas with an awareness of the bigger picture makes it possible for a design to embrace seemingly negative attributes to stimulate positive debate.

Production processes can also be explored and challenged to create unfamiliar outcomes to trigger possible new directions. The utilisation of combustible frameworks or structures that can initially support a ceramic artefact in a kiln will reveal incredible delicate forms. The innovative process is often explored and has incredible scope for imaginative experimentation.

Front

Front, formed in 2003, are based in Stockholm, Sweden. The four innovative partners, Sofia Lagerkvist, Charlotte von der Lancken, Anna Lingren and Katja Sävström, are all involved in the diverse aspects of the design journey, which particularly explores the product narrative, and the emotional language of ideas.

The designs have successfully questioned convention, and collections such as 'Design by Animals' (2003), 'Design by...' (2004), and the 'Story of Things' (2005) represent an ever-increasing portfolio of creativity.

Ceramic

Ceramic is a material that has been continually explored and investigated for generations by makers, artists, and designers, but it has also attracted the keen attention of researchers, engineers and scientists. Despite a seemingly ardent understanding of character and make-up a continual emergence of innovative practices and directions manages to broaden expectations. Ceramic has integrity and is used extensively in a broad array of disciplines, including design and engineering.

A predominant use of ceramic within design is the production of whiteware, which includes porcelain, bone china and earthenware.

Porcelain: A seemingly delicate and translucent material that can demonstrate impressive strength and rigidity. The characteristic attributes are acquired as a consequence of intense temperatures that the material is subjected to during firing.

Bone china: A form of porcelain with a typical translucent property, bone china is a sturdy and resilient material. The distinctive white aesthetic is due to bone ash being a dominant constituent of the composition.

Earthenware: An opaque ceramic that can be carefully controlled and exploited, but which retains a distinctive surface porosity unless conditioned with slip or similar finishes prior to firing.

Ingo Maurer
Ingo Maurer (b.1932) initially trained as a typographer in Germany and Switzerland before studying graphic design and becoming a freelance designer in America. Since 1966, after returning to Europe, Maurer has constantly questioned, created, and globally exhibited an extensive and inspiring collection of lights.

Ingo Maurer, with his team and associates, has investigated traditional and modern materials, lighting methodologies and visual languages with great appreciation of detail and sensitivity.

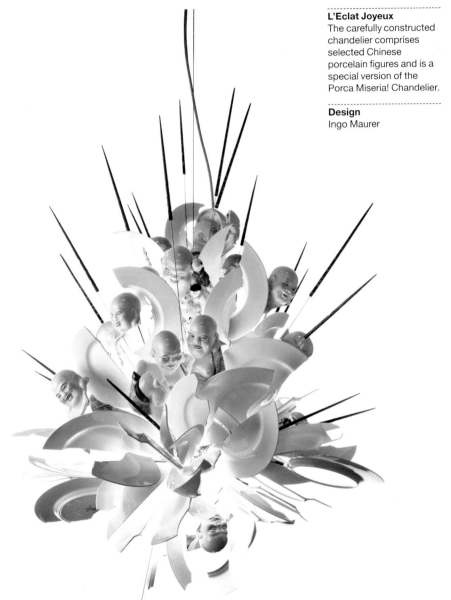

L'Eclat Joyeux
The carefully constructed chandelier comprises selected Chinese porcelain figures and is a special version of the Porca Miseria! Chandelier.

Design
Ingo Maurer

Plastic > **Glass and ceramic** > Paper

Paper

Paper has a unique reputation among designers that has been acquired through continuous experimentation and application through the generations. The versatility, elegance and simplicity of the material are beyond reproach.

Paper production

The production of paper relies on the knitting together of fibres from a suitable primary component. Various fibres have been successfully explored and experimented with for generations and have included linen and cotton, although it is wood that has evolved as the predominant source material. During the production process, which can be conducted through an automated or manual approach, the dominant constituent is crushed and reduced into manageable fragments or debris and then subsequently converted into a damp, cohering mass of matter. The accrued pulp is combined with water to generate slurry; a constant suspension of insoluble matter. The slurry is introduced to a mesh or net where it is allowed to settle uniformly on the surface. Continual agitation or vibration of the slurry mesh ensures that any excess fluid is disposed of effectively while also assisting in the marriage of adjacent fibres and the subsequent formation of a pulp ribbon.

Subjecting the accumulated sheet or ribbon to pressure and heat further ensures that unwanted moisture is readily extracted during the fixing stages. The chaotic mass of reconfigured fibres provides paper with its relative and intriguing characteristics including strength, flexibility, rigidity, and translucency; qualities that can be continually manipulated and refined.

Paper's versatility allows you to: crease, tear, knit, bend, curl, press, chew, pull, twist, snip, ruffle, pleat, paste, shred, crop, slash, scratch, soak, tangle, pierce, slit, roll, crumple, crush, mark, pulp, perforate, crimp, pinch, scorch, rasp, stamp, stitch and emboss it.

'… I never think about beauty, but when I have finished
if the solution is not beautiful, I know it is wrong.'

R. Buckminster Fuller, designer, author and visionary (1895–1983)

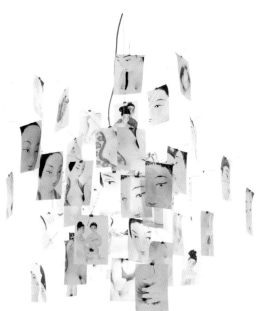

Left
Blushing zettel'z
A chandelier comprised
of 80 beautifully printed
images inspired by
Chinese porcelain.

Design
Ingo Maurer

Below
Zettel'z 5
A paper chandelier
comprising 80 pieces
of Japanese paper,
31 printed and 49 blank.
The printed sheets are
love letters in different
languages, and the blank
sheets provide an
opportunity for additional
messages. The complete
assembly effectively
diffuses light.

Design
Ingo Maurer

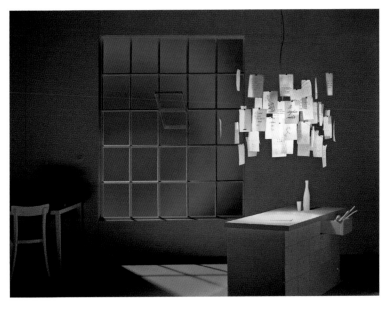

Practicality

The sheer purity and virginal appeal of paper is an attractive trait that is not always evident in other materials. The honesty of paper combined with a naïve, rudimentary innocence openly encourages exploration and ingenuity without restriction. A single sheet of paper can be incorporated effectively and efficiently into a proposal and its sustainable nature enables it to be easily replaced, adjusted or modified. Paper is perhaps somewhat underrated, and often substituted or unnecessarily overlooked in preference for more trendy alternatives, but the diversity, latitude and serenity that it offers is frequently beyond compare.

When it is possible to interact with a product directly and revive it through simple modifications or alterations the item becomes more personal and precious. The ability to cherish a simple, modest product and adapt it freely is seldom encountered; however, without compromise paper is usually compliant.

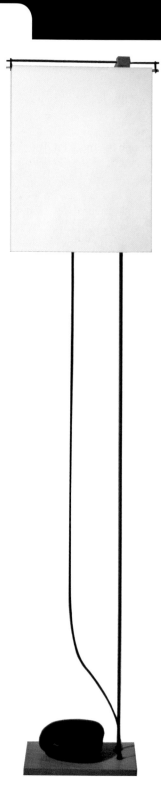

Lumiere Floor Lamp (1999)
This sustainable design utilises everyday objects, such as a found stone and a sheet of paper. The Lumiere Floor Lamp can be simply changed, adjusted or repaired by the user without any detrimental impact.

Design/photography
Stuart Walker

Imagination

The scope for the utilisation of paper in design is significant, and as imaginations broaden, more and more complex ideas are being realised through the medium. The different types of paper available, and the numerous coatings that can be applied, further increase opportunities. The dialogue evident between disciplines familiar with experimenting with paper forges the way for beautiful, elegant structures to emerge.

Accuracy is often a central theme in the development of structures made from paper, and providing this is recognised, the possibilities can be boundless. A repeated pattern, net or template that is cut with precision can be partially laminated to configure a detailed honeycomb framework capable of expansion and contraction. Despite individual components exhibiting limited suppleness, when they are able to work in conjunction with other similarly attached pieces the complete object is able to demonstrate great flexibility and movement. Such structures vary depending on the original net and the make-up of the material, however products with concertina properties are able to challenge other materials successfully in certain arenas.

The simplicity, lightness and grace of structures with flowing characteristics is appealing and convincing, but clearly defined paper slices are also used to generate more stable and static forms through processes such as laminated object manufacture.

The procedure builds a product from identified layers, which are laminated in a logical arrangement, eventually forming an accurate paper representation of an item. The difficulty with the manipulation of paper has often been its resistance to bend in separate directions at the same time; however the lamination of paper invites complex and sculptural forms.

Samurai Light: MaMo Nouchies collection (1998)
The attractive forms are achieved by the manipulation of fibres in the paper and succeed in softening the light. The term Nouchies is a tribute to the Japanese American sculptor Isama Noguchi (1904–1988). The MaMo Nouchies collection also includes Kokoro, Poul Poul, Jimken, Gaku, Wo-Tum-Bu 1, 2, 3, Con-Qui and Mahbruky.

Design
Ingo Maurer and team, and Dagmar Mombach

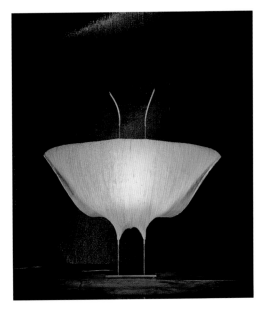

Glass and ceramic > **Paper**

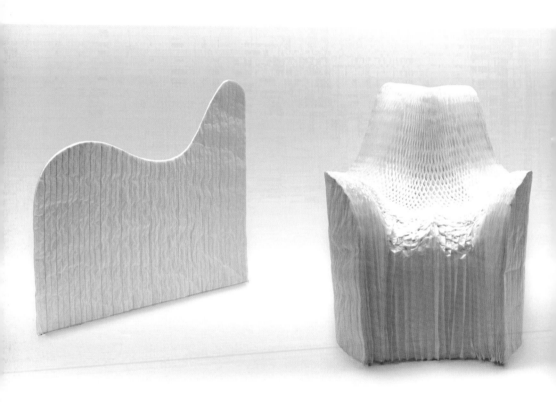

Tokujin Yoshioka
Japanese designer
Tokujin Yoshioka initially
studied design at the
prestigious Kuwasawa
Design School in Tokyo.
Developing an approach
to design inspired by
Shiro Kuramata and
Issey Miyake, Yoshioka
has created an
aesthetically considered
and pure approach to
design that understands
and respects material
context; an approach
that is effectively
demonstrated within the
paper patina and
elegance of Honey-Pop.
Tokujin Yoshioka has
created imaginative,
innovative and inspiring
outcomes for many
leading international
companies including
Driade and Vitra.

Above and opposite
Honey-Pop Chair
Glassine paper, accurately
cut and bonded, is used
to form the sensual
honeycomb structure.

Design
Tokujin Yoshioka

Photography
Nacasa & Partners Inc.

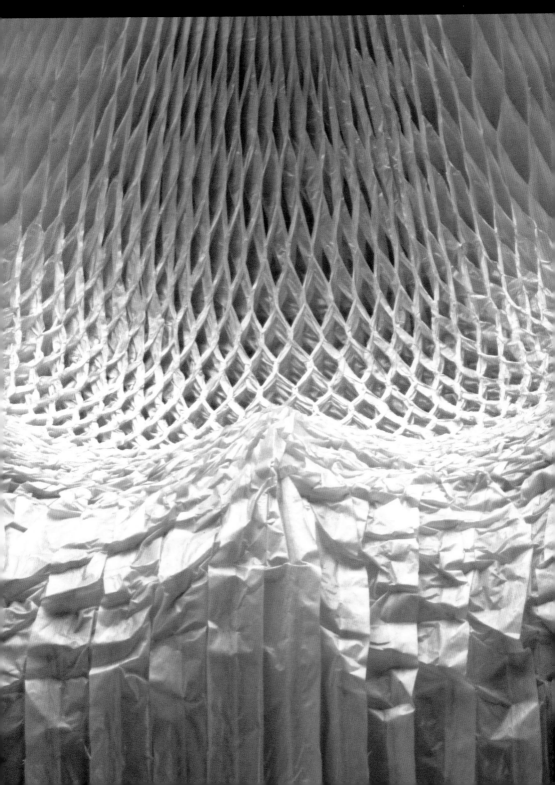

Flexibility

The flexibility and elegance of the molo Paper Fanning Stools is achieved using recycled kraft paper that is bonded together to generate a lightweight honeycomb structure. Increasing the amount of paper that is laminated and controlling the cell size provides the opportunity for the sculptural forms to be explored. The benches that are generated by the Paper Fanning Stools are free-flowing and can be stretched depending on user requirements or simply compressed for storage.

Paper softseating
The inspiration for the molo Paper Fanning Stool was simply a desire to have a system that could be adjusted as required.

Design
molo

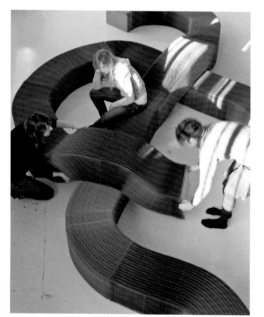

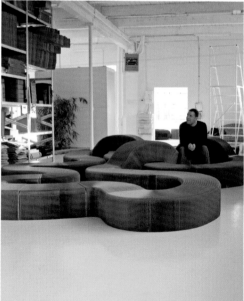

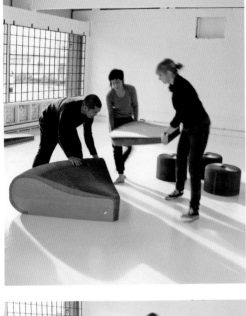

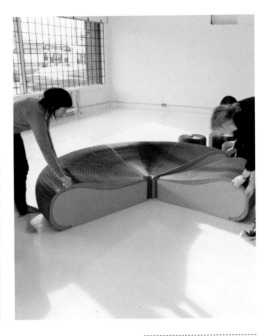

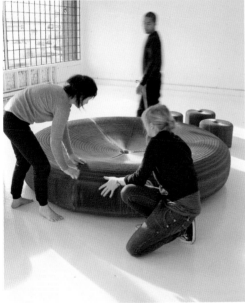

Kraft paper softseating
The softseating fanning
stools and fanning
loungers capture the
imagination of the user
and allow for countless
opportunities to be
explored. Despite being
constructed from paper,
the design exhibits plenty
of strength and flexibility
due to the honeycomb
structure. A desirable
feature of softseating is
that continued interaction
causes the surfaces to
soften and subsequently
adopt a natural aesthetic.

Design
molo

Glass and ceramic > Paper

Material selection

Stephanie Forsythe explains the use of materials in molo's designs: 'One of the projects that we give ourselves is to only use one material per product if possible; there is a sculptural elegance to choosing one material, such as paper or glass, and then figuring out how best to join it to itself. This approach also embodies practical efficiencies in manufacture and ease of recycling at the end of a product's life. And, most of all, it allows us to really focus and value the subtleties and strengths of a material, to learn something from a physical exploration.'

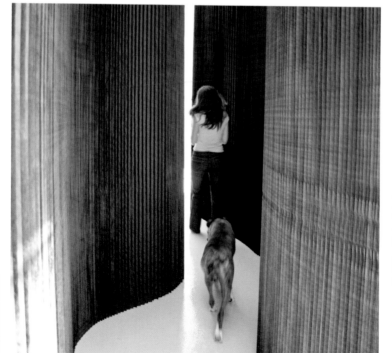

Paper softwall
The honeycomb construction of softwall uses lightweight tissue paper to create free-flowing structural forms. The angelic purity of the white tissue softwalls is enchanting and seductive; characteristics that are enhanced by its ability to capture and contain light. The black, opaque, paper softwall, reminiscent of charcoal, controls light differently, with a radiating lustre. The flexibility of the molo paper softwall allows for endless arrangements.

Design
molo

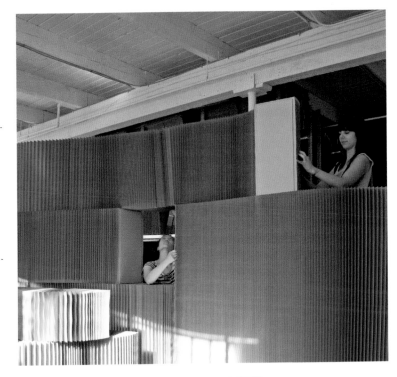

This page
Kraft paper softblocks
The strength of the softblocks, derived from their honeycomb structure, allows for individual components to be simply joined and stacked, creating versatile, fluid structures.

Design
molo

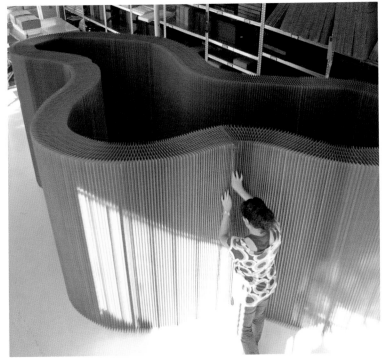

Layered construction

The construction of the Studio Libertiny Paper
Vase is initiated by the careful lamination
of 700 sheets of paper using wood glue and
a press to generate a maximum-density block.
The laminated paper is subjected to forming
and shaping on a lathe and manages to
respond in a similar manner to a solid block
of wood. Empathy with the material and an
understanding of process enables the elegant
form within to be revealed. A pattern that
was evident on the individual sheets of paper
becomes distinguishable on the final façade
of the sensitively formed vase. The
metamorphosis from solid block to paper
vase is affectionately completed using
controlled judgement and understanding.

Below
Paper Vase (2007)
Each sheet of paper is
printed with an identical
image of a tree, creating
a ghostly tree pattern on
the surface of the vase.
The project explores how
a block of paper can be
carved as if it were wood.

Design
Studio Libertiny

Photography
René van der Hulst

Opposite
**Production of Paper
Vase**

Design
Studio Libertiny

Photography
René van der Hulst;
Woodturner: Joost
Kramer. Concept: Tomáš
Gabzdil Libertiny

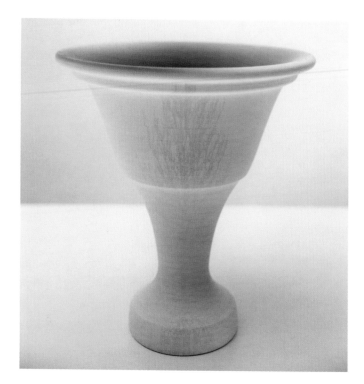

1. A block of paper is formed.

2. Images on the individual sheets are captured within the laminated block.

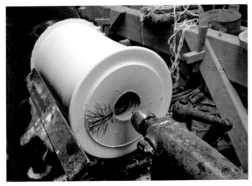

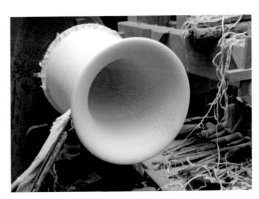

3–4. The block is turned in a similar manner to wood.

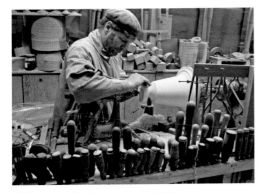

5. The form of the Paper Vase emerges.

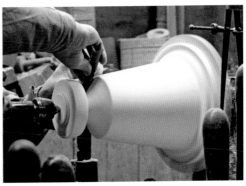

6. The Paper Vase is crafted and refined.

Glass and ceramic > **Paper**

Fantastic folds

Simply playing with paper, with no specific goal, can conjure up ideas that can be progressively refined. Paper can easily be adjusted and modified, although it can also be somewhat unforgiving. A reference to working the material in disciplines such as fashion and architecture provides an interesting insight into the range of possibilities.

Right and opposite
**Ink Blot Test Collection
and Blank Page
Collection**
The dresses are
constructed using origami
techniques.

Design
Sandra Backlund

Photography
Oscar Falk and Laurent
Humbert

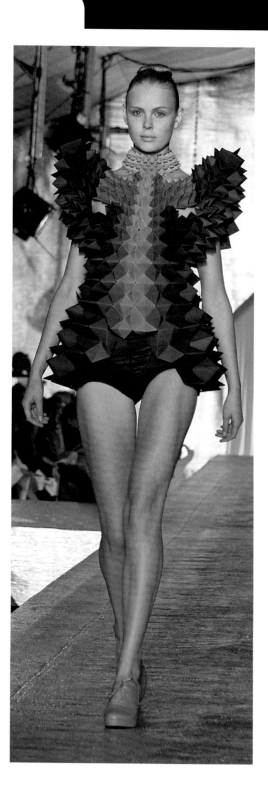

'I am really fascinated by all the ways you can highlight, distort and transform the natural silhouette of the body with clothes and accessories. I build my garments by hand from a couple of basic bricks which I multiply and attach to each other in different ways to discover the shape that I want. In that sense I approach fashion more like a sculptor than a tailor.'

Sandra Backlund

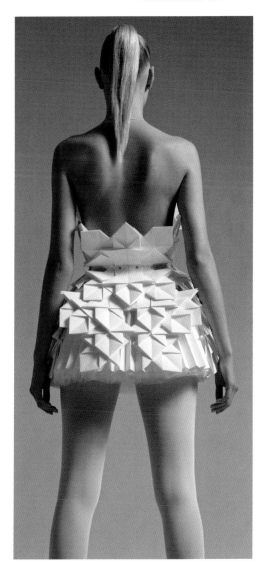
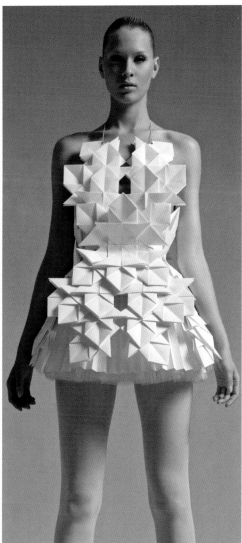

Producers are individuals, organisations or manufacturers that are capable of embracing a design and any ensuing logistics, and aim to ensure that it is effectively and efficiently realised. The producers' ability to understand consumer trends and thinking is usually critical in complementing the design process. Although it is possible for a liaison to be formulated at a stage where the design is effectively complete, it is often the case that a producer either instigates the development of a product or has a relationship with the design during its passage to manufacture.

Consultation with a producer, or an appreciation of their role, is important in affording sufficient weight to practical considerations. However, the idea-generation process should always be able to suggest an alternative, and equally viable solution, if constraints arise. If the design process cannot accommodate flexibility and compromise to some extent any physical realisation may not be viable.

The Millennium Chandelier (2004)
Constructed using 1000 expended party poppers. The dismissed, cheap, translucent containers are used to construct the genteel and elegant chandelier that manages to contrast mass production with 'one-off' sensitivity.

Design
Stuart Haygarth
www.stuarthaygarth.com

Material can be formed in numerous ways depending on the specific requirements of a design. Clearly, different materials can require different methods to be used in the forming process, and it is highly beneficial to understand a whole range of approaches and experiment wherever possible.

'What if...?'

To follow a suspicion that something might work 'if...' and allow a thought to be pursued from the confines of your imagination to the physical world is to experience a material journey that will inform and excite. The transition from thinker to maker is not always clearly defined and new thoughts can evolve as you work. A stubborn conviction to work and blend materials, to understand their relationships and to ignore taboo provides the opportunity to overcome restrictions. Obstacles and rules can be rejected when a tenacious attitude allows for creative expression and fluid thoughts to be entertained.

Playing with and mixing together different processes to develop potential is uplifting and can reveal new possibilities. Being able to occasionally break free from accepted limitations and having the foresight and intuition to disregard rational thinking and to question can be surprisingly helpful.

For this reason, many leading designers, artists and craftsmen set aside investigative 'fun time' in order to try out unrelated ideas and thoughts without pressure.

Bonding: There are several approaches that can be used to form a permanent or temporary bend in a piece of wood and many of the techniques can be applied to different material classifications.

Kerfing: A simple process that involves the production of grooves within a material that are usually separated by untouched areas of equal thickness. It is important to ensure that the removed regions are not too detrimental to the overall structure of the material, but provide sufficient space for an internal curve to manoeuvre into when flexed or bent.

Steaming: Subjecting wood to a moisture-based catalyst, by simmering, for example, can stimulate the temporary movement of internal fibres providing an opportunity for flexibility and permanent deformation within an identified range. In a situation where a material is inadequately prepared or goes beyond a particular limit, stress occurs and there is potential for material damage.

Ribs: Ribs can be constructed from flat material and used to generate a scaffold that more flexible materials can be adhered to. Thin material can also be used for lamination and gradually encouraged to adopt a curve or bend, often through the use of supplementary jigs and formers.

'My work never rests in one mode of thought yet strives to reach a high level of refinement. It is always evolving into the next piece and branching into different routes of exploration.'

Matthias Pliessnig

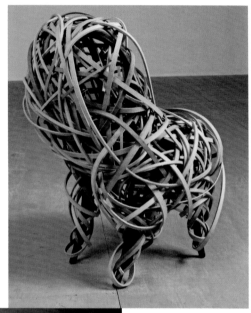

Left and below
**Thonet No.18 (2007)
and Insum Itineris**
Matthias Pliessnig created both these beautiful nest-like pieces using steam-bent oak.

Design
Matthias Pliessnig

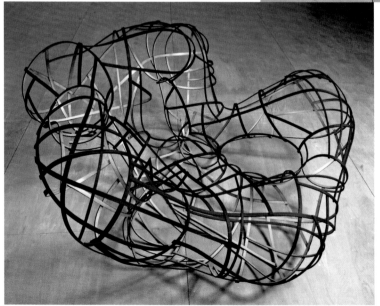

Vacuum-forming

Vacuum-forming is a relatively simple process where preformed sheets of material, often thermoplastics, are encouraged to adopt the contour of a predetermined form. The operation requires the construction of a suitable male former, which is identical to the desired shape, subject to necessary material tolerances. Various materials can be used to construct the former and selection is often dependent on the anticipated frequency of use and the quality of the product required. In situations where small production runs are anticpated; the life expectancy of the former may not be critical and construction may be from simple materials such as wood. However, a sophisticated former for large production requires a more substantial material, such as aluminium, that can be machined for exact detailing.

The development of the former is crucial to the success of the outcome and certain aspects of its construction must be considered carefully.

The process of vacuum-forming usually involves securely clamping preformed sheet material above an identified and suitable former. The sheet material is heated to a flexible state with care being taken to ensure it does not collapse or sag beyond return. At the point where the material is sufficiently heated it is directly presented to the former and draped over. The application of a vacuum under the sheet ensures that the material is pulled efficiently and, where possible, uniformly over the entire surface contour of the former. A vacuum is maintained until the material is suitably formed and has sufficiently cooled to ensure structural integrity.

If the former profile has not been suitably manufactured, problems will become evident during the vacuum process or when the former is ejected.

A former should always be developed to have slightly angled sides to assist in the separation between the male element and the constructed female part. The draft angle should not significantly impact on the aesthetics of a proposal, but its absence may cause difficulties during the separation process. The presence of undercuts, caused by depressions or projections on the surface of the former must also be avoided, as they will almost certainly prevent detachment of the parts or at least damage the product irrevocably. Preparation to assist in separating the parts may involve the application of a former release agent during the initial stages to prevent any unwanted friction.

The former construction should avoid tall or sharp design elements, as these are likely to create an uneven material thickness when the vacuum is applied and can cause it to rupture. Recessed areas also need to be managed properly and should not be too deep because of similar issues of wall thickness.

Complicated regions of the former, or zones where excess material may be anticipated, can result in the formation of fins or webs. The presence of such features needs to be prevented if possible as post-production removal will reveal large, unsightly pockets. Although vacuum-forming is often associated with the production of disposable products, the applications for its use are much broader and provide opportunities for significant exploration. Thermoplastics are popular in the vacuum-forming process, but any material that can be made pliable through the application of heat and then forcefully pulled over a former and retain its newly acquired shape has the potential to be used.

**Vacuum-forming:
avocado packaging tray**
The soft form of the
avocado packaging tray
lends itself well to the
vacuum-forming process.
The material becomes
much thinner as it is
stretched over the former,
so if the tray had sharp
features the rapid process
could lead to the material
being pierced. The stress
on the material can also
reduce overall colour
uniformity. Also, because
the tray is created over a
former, undercuts need to
be avoided.

Draft angle
A 'draft angle' is a slight
angle to the side of a
mould that assists in the
removal of a formed part.
A vertical side is often to
be avoided as it can
create friction that can
lead to damage of the
part during removal. For
example, a sandcastle
bucket has a slight angle
or taper to it so that the
bucket can be removed
easily from the formed
castle. The principle
is the same in moulding.

Forming > Moulding

Moulding a material requires a reconfiguration of form in some capacity and often involves the application of a stimulus or catalyst. There are many materials that are moulded or cast into desired forms and such processes have been tried and tested. Understanding the basic properties that enable familiar materials to be moulded also allows unconventional opportunities to be considered.

Injection Moulding

The injection-moulding process is often used for the medium to high mass-production of plastic products. Exact tooling ensures that items can be created faithfully and consistently to prescribed requirements. An injection-moulding machine is gravity-fed polymer material in pellet or powdered resin form. Compounded polymer is often formulated to ensure an exact cosmetic match is achieved with appropriate inherent characteristics. Virgin plastic is often colourless and can also be coloured through the controlled addition of dyes or liquid master-batches via the mixing hopper.

A barrel located below the hopper, containing a reciprocating screw, heats the material to a predetermined temperature, and viscosity. The screw prepares the volume of polymer for the injection process.

At the point when the polymer is appropriately heated, a plunger at the rear of the screw forces it forwards, causing a monitored amount of plastic to be injected into a desired mould. The temperatures of the various compartments of the machine, the polymer viscosity, the screw movement, and residual pressure within the mould are critical in ensuring that the product is formed correctly.

The mould, in contrast to the barrel, is kept cool to enhance the solidification of the molten polymer into the required form. When the molten plastic has been injected the formed object in the mould is ejected, prior to the plunger forcing more material back into the mould, which has been subsequently prepared.

The process of forming and reloading the machine is continuous with products being rapidly produced and removed.

The design of the product needs to be carefully considered if it is to be injection moulded. Every aspect must have been addressed and examined prior to production. All injection-moulded products will have the marks and scars of their creation; however, careful design can make some of them difficult to find, even under scrutiny.

1

4

Toy soldier scars

1. **Sprue**
 The sprue is a small scar
 on the surface of an
 object and is formed at
 the point where plastic
 entered the mould.

2. **Split line**
 The split line is the fine
 line that is formed where
 different parts of a mould
 have come together
 and subsequently split
 post-forming.

3. **Flash**
 Flash is the thin, rough
 plastic material that is
 occasionally evident
 around a split line and
 ejector pin mark. Plastic
 material can seep out
 during the forming
 process when moulds
 are not exact.

4. **Ejector mark**
 The ejector marks are
 scars, often circular, on
 the surface of a moulded
 product. The marks
 are caused when the
 newly formed item is
 pushed from the mould
 by ejection pins.

4

2

4

4

3

Forming > **Moulding** > Shaping

Rotational Moulding

Rotational moulding provides the opportunity to produce plastic objects with an internal cavity and a consistent wall section. The production of rotational-moulded products involves the monitored gyration of a temperature-controlled, but rapidly heated, mould. As the rotating mould temperature increases to a predetermined oven temperature, the powdered polymer begins to melt and flow. When the polymer within the mould is uniformly fluid under the rotational movement, it adheres to the internal walls and adopts the desired form of the mould face.

The rotary and spinning movements of the mould during the process ensures an equal distribution of material. As this low pressure process concludes, the controlled cooling of the mould produces products that are relatively stress-free. The formed product shrinks slightly, which assists in the subsequent removal of the item.

Different polymers can be utilised in the rotational moulding process. Examples include Polyethylenes, Polypropylene, Nylon 6 and Polycarbonates.

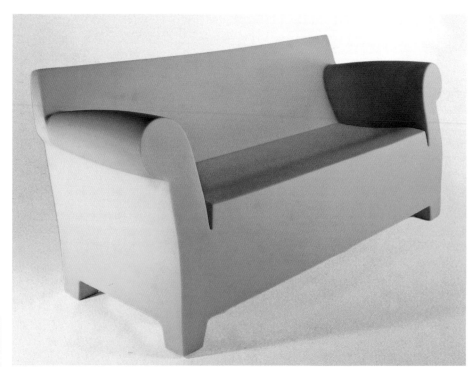

Extrusion

The extrusion process is a method commonly utilised in the formation of plastic. Material that is heated to a specific temperature is forced through a shaped die and assumes an identical shape. Although the process is predominantly used within the plastics industry and often requires an increase in temperature to act as a catalyst, the process can be adapted to form more unusual outcomes in alternative disciplines, such as the innovative Garden Bench.

Opposite
Bubble Club sofa (2000)
The single component approach adopted by the Bubble Club series provided the opportunity for traditional fabrication to be effectively challenged with a contemporary, fun and elegant solution.

Design
Philippe Starck and produced by Kartell

Below
Garden Bench (1999)
Natural debris collected in a vertical hopper descends and forms a continuous bench that can be sectioned to create individual seating.

Design
Jurgen Bey,
Studio Makkink and Bey,
for Droog.

Photography
Marcel Loermans

Forming > **Moulding** > Shaping

Blow-moulding

The blow-moulding process requires the generation of a parison, a preformed shape, which is created by an extrusion or an injection-moulding process. The creation of the parison is the initial stage of the overall process as it is located at the entry of a predetermined mould. Blow-moulding is used to create hollow objects; the method is similar to inflating a balloon inside a form so that it takes on the internal shape of the mould. The preformed shape expands into the mould through the use of pressurised gas that forces it outwards in all available directions. As the parison comes into contact with the inner wall of the mould it attaches and replicates the contour. When the mould and the material cool down the form created from the parison remains and can be removed.

The blow-moulding process is used to create a diverse range of products, but all have the common characteristic of an internal cavity created by the gas expanding the plastic during production.

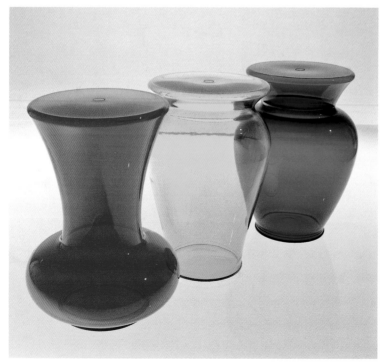

La Bohème (2001)
The blow-moulded polymethylmethacrylate forms the multifunctional stool.

Design
Philippe Starck and produced by Kartell

Producers

Freestyle
Blow-moulding
The visually appealing free-style blow-moulded vases manage to effectively merge the boundaries of one-off appeal with a mass-produced aesthetic. The innovative vases capture the imagination with their simplicity and charm.

The organic-looking forms are created by air into PVC tubes or pre-form tubes.

Design/photography
Jonas Samson

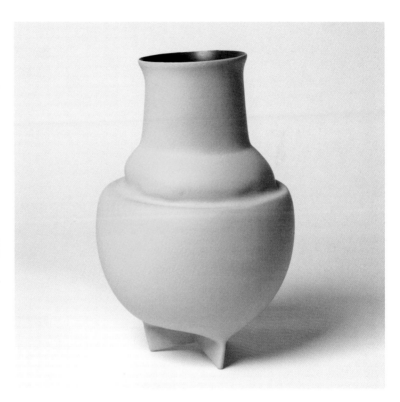

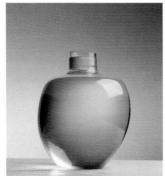

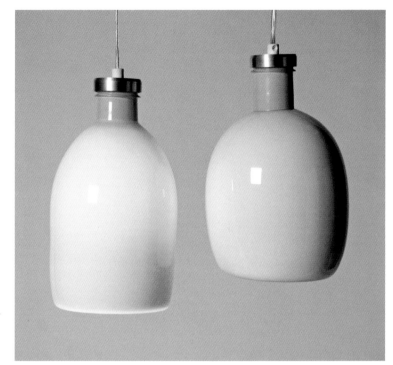

Freestyle Blow-moulding Lampshades (2007)

Jonas Samson's freestyle blow-moulding experiments recognise the importance of mass-production and the attraction of a craft aesthetic, and successfully combine both approaches. The thermoplastic Polyethylene terephthalate (PET) lampshades are free-formed by blowing pressurised air into preforms to generate an exciting and visually stimulating design.

Design
Jonas Samson

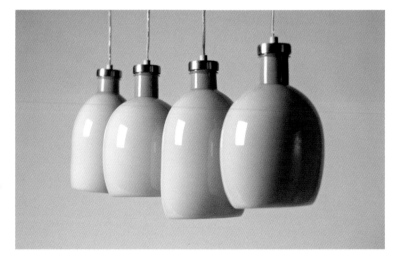

Shaping a material to generate an explicit form is often an exciting process that combines intuitive and experimental approaches. If the unique properties of a material are understood and respected during shaping an intimate relationship between form and function can emerge.

Contour

The ability to reconfigure and shape a surface, to sensitively manipulate and discover textures, is a vital skill for any designer. An exciting texture that undulates and appeals is much more than a functional skin or shroud; it is an integral functional and emotive element of a design. This is amply demonstrated in Helen Amy Murray's beautiful designs below.

Flowers and plants collection
Nature and intricate carvings in India inspired these internationally acclaimed relief textiles.

Design
Helen Amy Murray

Photography
Marcos Bevilacqua

Moulding > **Shaping** > Fabrication

Accuracy

In product design terms, accuracy and
precision are similar but not the same.
It is possible to have different degrees
of accuracy, but something is either precise
or it is not. Accuracy is often regarded as
the ability to perform a task with exactness,
but should be considered as the obtaining
of a predetermined target within an
acceptable tolerance.

A product that has been created by a skilled
individual with a strong understanding of and
feel for their material, can be just as accurately
produced as a mechanically produced item.
The accuracy of a product is the proficiency
with which it can perform its identified
objective. Despite material and technical
developments accuracy is not always
achieved, and there is still much to learn from
imprecise, visceral approaches and methods.

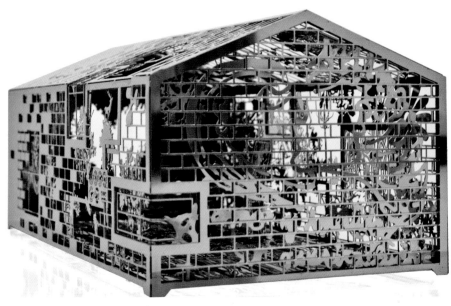

Fabrication

The fabrication of a product involves the assembly of preformed components. The different parts may have been subjected to an array of diverse and often complex production methods prior to the assembly of a final article. The methods for fabrication are wide and varied, with construction of a single product often incorporating several different approaches.

Wood

Joints produced using traditional methods with hand tools, or created using tailored technology, are often associated with quality. Common joints that are used to assemble items include butt, dowel, dovetail, end lap, mortise and tenon, mitre, and rabbet. Although some of these joints are stronger than others, and may include dowel or pegs, the addition of adhesives or fixings such as screws and nails can substantially increase rigidity.

Glues and resins can be used to fabricate a product without the need for joints or further fixings. However, unless there is a considerable surface area to be bonded the join is likely to be unstable. Macerated wood can be combined with resins and formed into physical products; these are usually utilised to form boards that become the basis for mass-produced utility items.

The fabrication of utility products usually relies on the use of fixings rather than joints, although these can be as sophisticated as the crafted elements. Fixings such as socket screws, cams, cross dowels, and joining blocks are frequently used in the fabrication of temporary or inexpensive products.

Opposite top
Fold to fit table cloth
The laser cut dotted lines on the cloth assist in the accurate setting of tables, while evoking memories of more traditional lacework.

Design
Chris Kabel for Droog

Photography
Droog

Opposite bottom
House of Textures
The beautifully detailed House of Textures by Tjep successfully uses laser-cut metal throughout the construction and incorporates a broad range of references including jewellery and graffiti.

Design
Tjep for Droog/ Friedman Benda

Photography
Bas Helbers

...t approach in the ...cted items and a broad ...exist depending on the ...ne material being bonded and the ...ne product. The foremost techniques ...o be Arc, Oxyacetylene, MIG, and TIG ...elding; processes that manage to effectively create a physical bond between adjacent metals through melting targeted areas which subsequently fuse.

In addition to the physical marriage, the bonding of metals can also be conducted through adhesives as a temporary or permanent solution. The development of adhesives provides fantastic opportunities for consideration. As with most materials, fixings provide a simple and productive method for fabrication. Fixings such as bolts, rivets or screws can demonstrate remarkable strength and withstand extreme pressure.

Plastic

Plastic that has been shaped through a particular moulding or forming process can often include an integral feature that assists in the joining together of remote parts. In particular, plastic mouldings provide the opportunity for a variety of fabrication requirements to be contained within a single part. Push-fit and screw-fit elements, fasteners, couplers, clasps, and hooks can all be included within the make-up of a part.

A broad range of adhesives exist for the bonding or welding of plastics. However, care needs to be taken to ensure that such substances do not have a detrimental impact on the materials being fabricated. In the bonding of some plastics it is necessary to physically apply an adhesive to a targeted region, whereas in some liquid-based adhesives the solution often relies on exploiting capillarity. External physical fasteners that can be used to construct an overall product are similar to those for most other materials and include poppers, screws, and rivets.

capillarity *n*. the tendency of a liquid in a capillary tube or absorbent material to rise or fall as a result of surface tension. Also called *capillary action*.

Stunning variants

The emergence of innovative materials and processes continually provides exciting opportunities and direction. Convoluted visual languages can be successfully explored and reinvented so as to appeal to a more contemporary audience. The fabrication methods of individual components and their subsequent transformations into completed objects are being subjected to an inspired make-over. Fabrication techniques and approaches have much to offer, and are capable of combining the personal with broad appeal.

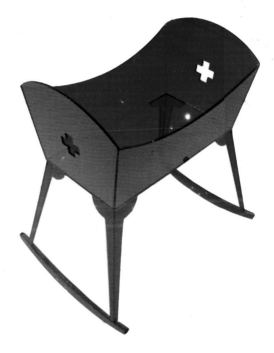

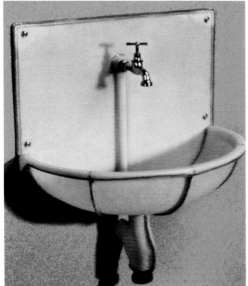

Left
Felt washbasin
The felt washbasin, by the 'industrieel maatwerk' (industrial tailor) Dick van Hoff for Droog, is constructed from polyester and industrial felt stitched together with black thread.

Design/photography
Dick van Hoff

Above
Red Cradle.
Techno Chick.
The translucent red acrylic cradle is laser-cut and manages to reinvent the traditional cradle with creative imagination. The cradle is part of the stunning Nursing Room 0+ collection by Nika Zupanc.

Design
Nika Zupanc

Shaping > **Fabrication**

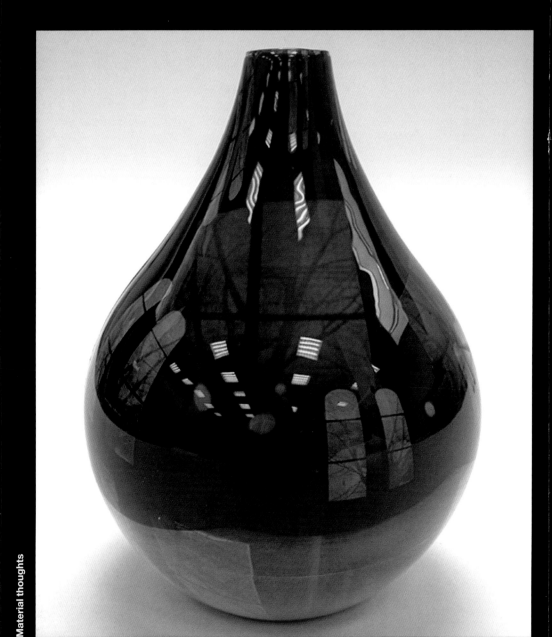

Reflection Vase
The 'design by surroundings' collection includes this intriguing vase: 'The decoration on the vase is made of permanent reflections. The vase tells us some of its history – the new reflection blending with the old like a double exposure.' Front

Design
Front

Photography
Anna Lönnerstam

To consider a 'what if?' scenario is simple, and to generate ideas is not too problematic, but what if the ideas were taken further, and what if they did become physical and exciting entities. What prevents the journey from probable to tangible? It is important to question conventions, but finding viable alternatives can be difficult. Anything original needs time to settle and to gain understanding. The transition from the 'what if?' to 'have done' needs to be nurtured and respected.

A stubbornness and hunger to achieve, to explore and probe, and be completely committed to a cause is to succeed. The 'what if?' must become 'will be' if innovative and imaginative results are to surface. The process of achieving the unfamiliar must not be swayed by negativity, although it is sometimes necessary to have sufficient courage to abandon problematic pathways and reconvene thinking to reveal a suitable alternative.

How can materials assigned to specific tasks be incorporated differently and given a new lease of life? What happens when the scale and proportions of the familiar are challenged and tackled from a different direction? Alternative thinking breaks the rules and requires the intrepid imagination of an adventurer.

Texture and colour

Far from being a peripheral aspect of a design, textures and colours can literally make or break a proposal and should therefore be considered carefully from the outset alongside other fundamental design features. Colours, textures and other associated finishes are an intrinsic element of any project and should be the result of positive, informed selection, rather than being left to chance or retrospective selection.

Inspired

Inspiration for colours and textures is boundless; the difficulty is in understanding what is needed or what is desired and how it can be accomplished. Occasionally a chance experiment or the use of a process that is perhaps more familiar to another discipline or method of working can have a dramatic effect.

A voracious appetite to consume all possible triggers in an attempt to identify a suitable direction is desirable, but not necessarily practical. Enquiry, dialogue and an investigation strategy that uses literal and lateral approaches are all important, but this process needs to be manageable. It is often the simple ideas, using simple observations, that succeed. Consideration to the story that is being told by the product and the overall visual language informs direction and assists in the refining of suggestions.

Inspiration can be sought and absorbed, but it can also be distributed to others through conversations and encouragement. It isn't possible for a single individual to hold all the answers, or to know all the questions.

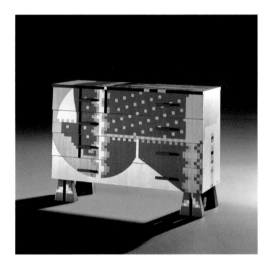

Above
The Zanotta Calamobio Chest-of-drawers (1985–1988)
The abstract and avant-garde visual language of this design, with its pixelated, coloured surface, reflects the designer's ability to successfully question the constraints and direction of mainstream thinking.

A co-founder of Studio Alchymia, a member of Memphis Alessandro Mendini has had an influential impact on the creative direction of numerous leaders in design such as Alessi, Swarovski and Bisazza.

Design
Alessandro Mendini

Opposite
The Reflection Cupboards
The cupboard façades relay the reflection of a room from a previous point in time, while also capturing a present identity.

Design
Front

Photography
Anna Lönnerstam

In their FOUND collection, Swedish design group Front explored the distinctive, individual elements of otherwise anonymous products. The surface of cupboards within the collection were transformed by the physical addition of a reflection; a story of a room that had been captured at a particular point in time and applied to the product. The approach managed to transform a somewhat innocuous item into something that generated curiosity and intrigue and successfully questioned product relationships.

Texture and colour > Scale and form

Striking – dare to be different

For a product to be striking and have the capacity to enthral, the designer needs to take a chance and try something that might be unexpected or considered unfeasible. An orthodox approach, with restraints and a conservative attitude, will often provide a satisfactory outcome, but satisfactory could be considered dull and boring. Mundane products are constantly under threat from the products that dare to be different, capture the imagination, instantly excite and challenge stereotypes.

A creative relationship between the University of Arts and Design Lausanne (ECAL), Swarovski crystals, and the prestigious snowboard manufacturer Nidecker culminated in a cross-discipline approach during the development of the ECAL, Nidecker and Swarovski snowboard. The expertise of Swarovski in producing the striking crystal stones along with their advanced knowledge of fixing stones, combined with the technology of Nidecker and the creativity of all partners, resulted in a series of striking snowboards targeted at open-minded individuals.

The Nidecker snowboards were initially treated to attain a special grip and then flathead crystals were applied using adhesive. The outcome was a crystal snowboard that captures the splendour of Swarovski and managed to retain the characteristic strength and flexibility of Nidecker.

Experimentation with different styles, fashions and cultures can reveal opportunities that an individual or manufacturer might not even know they want until they see it. Emotional attachments can prompt a seemingly illogical desire in an audience – they want it, but they don't know why. To identify products that might instigate such a response requires confidence, an open mind and the desire to question. Such products are the 'catwalk' leaders; they develop the market and influence thinking. Understanding a user profile, what an audience responds to and the activities they engage in or would like to be associated with, provides an insight into what might be well-received.

An appreciation of product purpose and function is always critical as successful design begins with an understanding of how the product is really used. The perception and the reality may be very different and failure to comprehend the true function of the product is almost certainly going to be detrimental to the design.

To experiment and propose something that will instantly create debate due to a juxtaposition of untested styles and ideals is essential. Not to experiment and not to question, not to observe real scenarios or understand what is actually occurring is to simply trundle on with dangerous dullness.

'Crystal Snow' the ECAL, Nidecker and Swarovski snowboards (2008)
Industrial design students created magnificent customised snowboards, under director Pierre Keller at the University of Art and Design Lausanne (ECAL) in Switzerland and in conjunction with Nidecker and Swarovski crystal. The beautifully inlaid crystals on the Nidecker boards are unexpected and demand respect, helping these exclusive boards to successfully couple attitude with sophistication.

Design
ECAL/Delphine Rumo and ECAL/Mads Freund Brunse

Photography
ECAL/Florian Joye

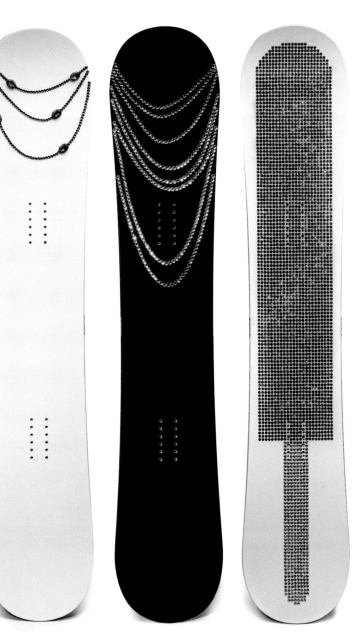

Texture and colour > Scale and form

Scale and form

Scale and form both have a significant impact on how a product is perceived and received. Modification and adjustments in these particular characteristics can elevate an object from being uninspiring, to having a confident presence that is unavoidable. Form is not a shape; it is an understanding of requirements, with intrinsic emotive and functional responsibilities.

Playing with convention

An instinctive ability to summon the unfamiliar, to ignore preconceptions and play with scale and form can reveal irresistible and compelling possibilities. To play with the unknown, to seemingly abandon rules and rely on intuition may appear dangerous, but frequently such practices produce results that enthral and bewitch.

A simple reduction or increase in scale can have significantly striking outcomes as an object is diverted from the ordinary to the exciting.

Spanish designer Jaime Hayón continually explores ideas and thoughts through sketchbooks and notebooks, considering material combinations, contrasts and applications, and thinking about scale and the configuration of form. It is this ability to constantly probe, record, think, dream and ponder, that enables fantastic and highly creative items to emerge. The ability to move away from the familiar and play with convention is an important aspect in the manipulation and understanding of materials.

Cactus 2 and Muñeco (Doll)
Jaime Hayón's Cactus and Muñeco (butler doll) were part of the impressive, and beautifully elegant, Bisazza: Hayón Pixel-Ballet installation that was produced for Salone. Bisazza is recognised as being at the international forefront in the production of glass mosaic. The butler rests within the Pixel-Ballet surrounded by Cactus and Organic Pixel vases, with their attractive and sophisticated mosaic inserts from the Bisazza Home collection. The installation manages to merge art forms and industrial applications, with Organic Pixel vases such as the 'White Organic Michelin'.

Design
Jaime Hayón

Photography
Klunder

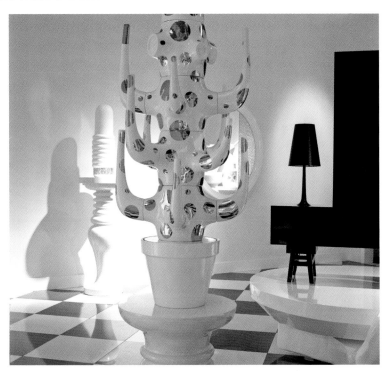

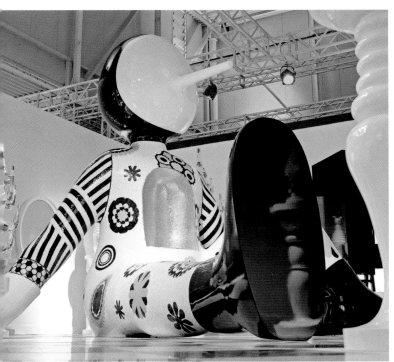

Structure

The structure of a product is, of course, an integral trait that requires detailed attention and comprehension. The collective functions of the individual parts determine whether a structure is suitable and appropriate.

Impressive

Referencing and individual experiences of different structures conjure up an extensive list of possibilities, and the ability to imagine compositions in alternative sizes, materials and configurations is useful. However, encounters and understanding can be limited, and familiarity with certain approaches can constrict the potential available. It is necessary to think beyond the familiar and re-evaluate materials, questioning why they are selected and what they could offer. There are arguments against, and reasoning for, all materials and to simply accept convention does not allow for many worthy options to be presented.

The motive for utilising a particular material in a certain way may be sound, especially when it embraces accustomed values and ideals, but consideration should also be given to other emerging suggestions.

The context of where a material is being used needs assessment, as it often happens that something has 'always been done that way' when better solutions are available.

A material can develop credence in unfamiliar territories when it is allowed to demonstrate its suitability to perform but unless the material is provided with such an opportunity its potential will remain dormant. There are many misconceptions about numerous materials relating to areas such as strength or durability, but their actual properties can be revealed with a questioning attitude and with trial and error.

Morphologies offer much potential to those who can envisage alternatives or capitalise on previous developments, but accumulated bias towards some materials can be a barrier that is difficult to overcome.

Shigeru Ban
An engendering of unique and imaginative structures, which demonstrate cultural empathy and environmental sensitivity, is a challenge that Japanese architect Shigeru Ban continually manages to embrace. Exploring the constraints and characteristics of materials that are perhaps not instantly associated with structural solutions, Shigeru Ban effectively and succinctly communicates that paper and card can successfully couple the magnificent and the practical.

The mix of economical and low-technology considerations to generate a sublime poetic language that is evident in structures such as the Japan Pavilion Expo 2000 in Hannover and the Paper Bridge in Remoulin requires an intimate understanding of material capability.

Paper Bridge (2007)
Japanese architect
Shigeru Ban utilises
recycled cardboard tubes
in the structure of the
Paper Bridge, Remoulin,
France.

Design
Shigeru Ban

Photography
Didier Boy de la Tour

Architectonic *adj.*
having a clearly defined
and artistically pleasing
structure

Morphology *n.*
a particular form, shape,
or structure

Scale and form > **Structure** > Tangential

Stiff or strong?

The stiffness of a material relates to its responsiveness to pressure and stress, or simply what it is able to withstand before irreparable damage is incurred. Stiffness can describe a material that is supple or pliant, but can equally be applied to something that is resilient and stubborn, as it is measured by the amount of tensile or opposing force that needs to be applied to trigger or instigate a breakage. The difference between stiffness and strength is a fundamental issue. The characteristics are often assumed to be the same when in fact they refer to the pre- and actual destruction point properties.

It is entirely feasible for an individual material to portray opposing attributes relating to strength and stiffness. A material may not exhibit much flexibility when subjected to stress, but can be broken with minimum force, while another material may display an enthusiastic capacity to bend and not readily yield. Obviously a material can have limited flexibility and strength, or excessive movement and strength. The assumed perception of a material is not always the actual story and so materials must be evaluated and considered carefully irrespective of preconceptions. The compressive or downward strength of a material can be impressive, but a singular vertical dimension can be vulnerable to opposing forces. Considering compression forces from multiple directions provides opportunities for the construction of complex structures as the physical downward strength forces metaphorically lock the individual components together.

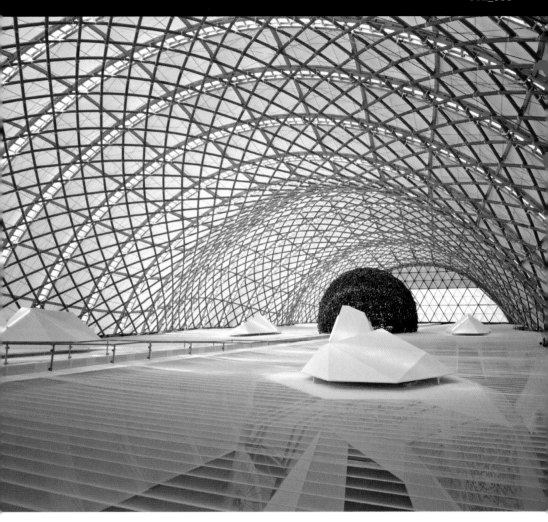

Opposite
Paper Studio (2003)
The Paper Studio,
at Keio University,
Fujisawa, Kanagawa,
Japan, designed by
Japanese architect
Shigeru Ban.

Design
Shigeru Ban

Photography
Hiroyuki Hirai

Above
Japan Pavilion (2000)
The cardboard tubes used
to fabricate the strong
and intricate morphology
of the Pavilion are
eventually returned to
paper pulp when the
structure is disassembled.

Design
Shigeru Ban and Frei Otto,
for Expo 2000,
Hannover, Germany

Photography
Hiroyuki Hirai

Improvising opportunities with limited resources is an important aspect of the enquiry process. Too often proposals are put forward which assume inexhaustible resources, but when available resources are limited designers are forced to think laterally and consider almost maverick options. Indeed, limitations can often reveal an abundance of creative alternatives that would not otherwise see the light of day.

Deviation

Deviation from the norm, entertaining the perverse and the oblique is to scout for a breakthrough, a situation that can radically change the ways that things are perceived and carried out.

Continually and constructively reviewing methods and applications, and searching out better and more effective solutions is vital to the discovery of creative solutions. Understanding that products and their components do not need to retain their initial make-up, but can have a transitional state that fluctuates and embraces different conditions, can forge interesting and exciting opportunities. A perfect example of this is the Office in a Bag (OIAB) designed by Inflate, a lightweight room system that packs down into a conveniently portable bag.

It is produced in rip stop nylon and sewn together, creating a lightweight, attractive structure. The Office in a Bag design was, according to Nick Crosbie, produced 'in response to numerous requests from architects for internal meeting rooms and break-out spaces'. The inflatable, elegant and fun structure provides an effective and innovative solution to a common problem through questioning what is required and demonstrating a comprehensive understanding of material potential.

'The idea was to design out all the features such as doors, roof etc.
This then allowed for the design to be the simplest piece of small architecture.'

Nick Crosbie, Inflate

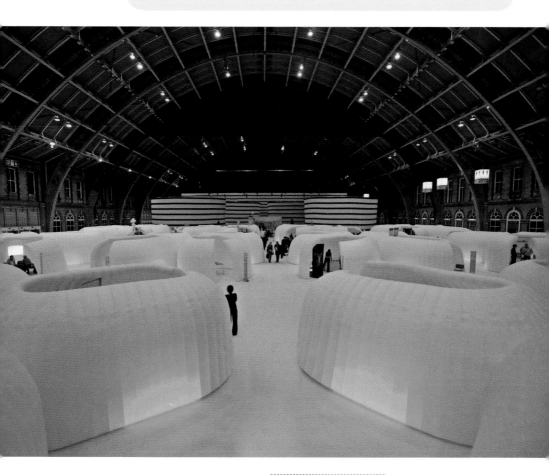

Office in a Bag (OIAB)
The sensual OIAB inflatable system is a multifunctional structure, designed for indoors; it is a descendant of the original Inflate products designed by Nick Crosbie. Inflate formed in 1995 with the intention of merging fun and function within their products.

The Inflate approach of physical enquiry and a passion to innovate markets has resulted in a fantastic array of ideas that can respond effectively and efficiently to user requirements.

Design
Inflate

Structure > Tangential

Unexpected

Observing the way materials behave in certain environments does not mean that they should not be considered for an unexpected situation or application. A material may be almost ideal for a particular application apart from a single attribute, but unfortunately a lacking characteristic can, if not explored, render it useless. Exploring material difficulties should be conducted in the same manner as any other problem. Why is the material inadequate? Why does it need the missing property? Why can't it be done another way?

Questions need to be asked and options need to be presented to overcome often simple barriers. If the material is of interest, then it is worth exploring further to see what can be achieved.

Dry Tech was a project conducted by Droog in 1996 and generated a number of products that challenged preconceived thinking. Materials not usually associated with having particular traits were explored and the outcomes managed to surprise observers, stimulating debate about conventions and opportunities.

The 'knotted chair', designed by Marcel Wanders, fuses the emotive appeal of traditional craftsmanship with contemporary sophistication and advanced thinking. The chair, reminiscent of crafts such as crochet and lace, manages to defy expectations with its elegant, graceful and strong presence. The characteristic of the craft has been captured, while the anticipated delicate structure has been redefined. The chair is constructed from thread that combines the synthetic fibre aramid with carbon fibres, providing the essential strength. The completed form is achieved by suspending the prepared chair and allowing gravity to determine the final language.

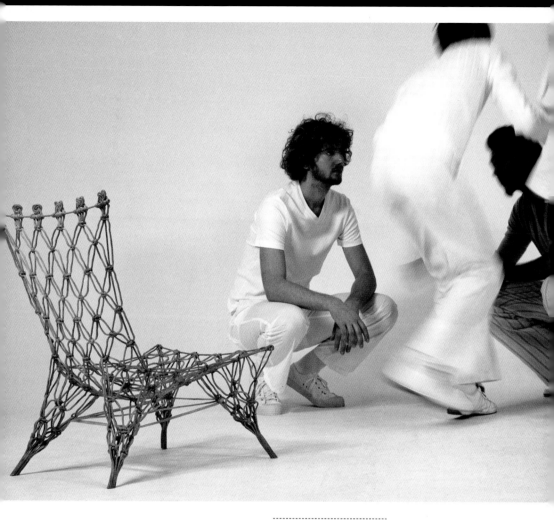

Knotted chair (1996)
The golden yellow colour
of the design is obtained
from the use of the aramid
fibre and rigidity is
ensured by impregnating
the knotted chair with
epoxy resin.

Design
Marcel Wanders for Droog

Photography
Robaard/Theuwkens

Styling
Marjo Kranenborg

Structure > **Tangential**

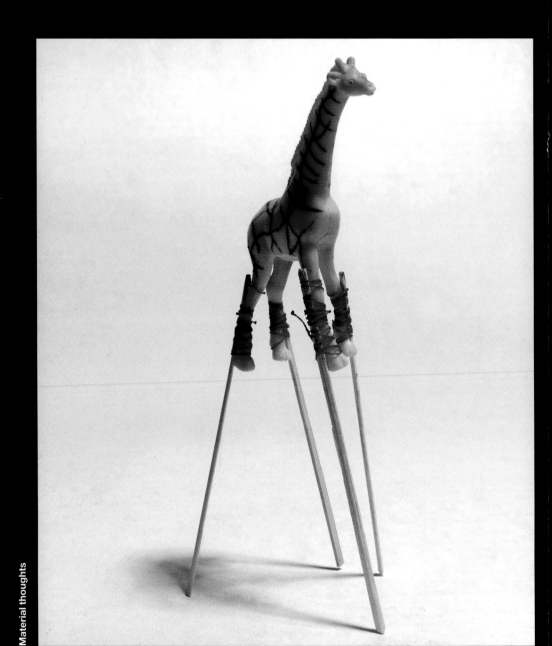

Experimental approaches with materials provide the opportunity for truly innovative ideas to surface. These experiments usually have an objective but can also be more abstract; more surreal and random. It can be productive to occasionally rely on your subconscious and instinct to help you 'feel' what is required. A visceral approach that allows you to have an unrehearsed and informal interaction with a material can throw up exciting possibilities. Impromptu trials and exercises don't need to be accepted or have to conform to standard rules of design, they are opportunities to allow thoughts to spontaneously grow and discover a possible new direction.

If everybody did the same, thought the same and responded the same then nothing exciting would occur, just more of the same. In playing, improvising and trusting thoughts to wander with materials for a while, previously unforeseen opportunities arise.

Speculative experimentation should not dominate thinking, but can perhaps be allowed to run wild occasionally when more accepted methods become dull and ordinary. A juggling of chaos and order within the design process provides a useful balance.

Bully
'Bully' is one of hundreds of experiments that the designer Matthias Pliessnig calls 'Ad-libs'. The appealing, small sculptures constructed from random objects tell a story and are an intuitive problem-solving process.

Design
Matthias Pliessnig

Abnormality

It is often difficult to determine what is 'normal' and what is 'abnormal'. Materials that appear to conform to a particular genre can often reveal unexpected qualities and applications when tested. Many traditional materials are now being subjected to a makeover and acquiring additional unfamiliar traits that allow them to be considered for previously unforeseen applications.

Impostors

The emerging generation of 'impostor' materials, which reject familiar characteristics and embrace the apparently strange or peculiar, are challenging their modest predecessors for attention. Experimentation with materials is successfully modifying compositions, with examples such as transparent concrete, ceramic foam and even material that conducts electricity providing fantastic new opportunities for designers.

Materials that were not flexible have deviated from their constraints and have an unprecedented suppleness, opaque materials are transparent, and previously ponderous materials have agility.

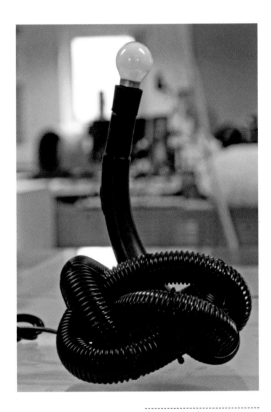

Get knotted
The 'get knotted' lamp is constructed using the redundant parts of a vacuum cleaner. Although only a suggestion, the configuration provides a simple and workable basis for development.

Design
Product design University of Lincoln (UK)

Photography
Clive McCarthy

Abnormality *adj.* Deviating from what is normal

Normal *adj.* Conforming to a standard; usual, typical, or expected

Improvise *v.* Produce or make from whatever is available

Ad-lib *v.* Speak or perform without preparing in advance

Hybrid *n.* A thing made by combining two different elements

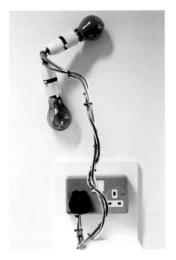

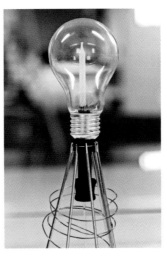

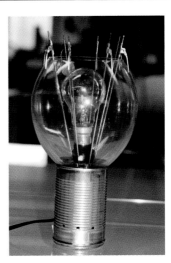

Twisted
'Twisted' uses only the essential elements of a light and manages to bypass the body. Intertwined cables that service separate lights provide a flexible and structural support.

Design
Product design University of Lincoln (UK)

Photography
Clive McCarthy

frank lab 1, 2
The 'frank lab' lights are somewhat reminiscent of a Frankenstein creation. The lights are assembled using very basic parts and suggest a possible direction for development. The frank lab lights have the potential to be maintained, rebuilt, adjusted or modified by the user.

Design
Product design University of Lincoln (UK)

Photography
Clive McCarthy

How to...
Ideas and directions can be hidden within existing products, and await discovery or release. The systematic deconstruction of items to identify the individual components provides a set of parts that can be considered in a different way from their original use. The individual artefacts should be held and felt, understood and viewed from unfamiliar angles. What could they inspire and what could they become? Materials and scales can be changed within the imagination in order to try to understand what could be, 'if only'. Think about why things are done the way they are and whether they could be done differently.

Abnormality > Improvise

Designers often tell stories through found objects to bring together disparate forms, and amalgamate styles that invite either harmony or conflict. This process captures the imagination and provides an opportunity for visual languages to be interpreted differently.

Simple sculptures

Building ideas with randomly sourced objects is a personal and meaningful practice. The creations have an emotive attachment and represent an inner feeling that is perhaps not often revealed by an individual. Different makers will usually tailor the sculptural process in accordance with their own particular way of working. Items can therefore be very eclectic and exhibit a characteristic charm. The process may simply be the realisation of a subconscious thought, investigating new ideas guided by the need to develop exciting, suggestive and rewarding possibilities.

In other circumstances the assembly of found objects may be in response to a very specific idea that needs to be explored further. In this case the sourcing of materials will need to be much more selective to ensure that found items have the necessary properties to embody the idea. There is no doubt that these quick approximations are important and play a significant role in the overall design process, ensuring that subsequent efforts are carried out correctly and efficiently.

G-set

'Ad-lib' designs
'My small sculptures are tiny thoughts or poems often about mending a broken object. I sit down to take a break from my larger projects and look through [a box of] junk to relax. Then, I think about what the story is behind [each] small object… and I begin building the story.'
Matthias Pliessnig

Design
Matthias Pliessnig

Experimental approaches

Clothespin 11

See

Strawberries

Periwinkle

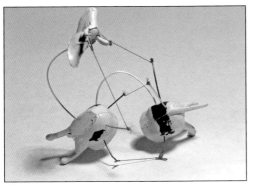

Snafu

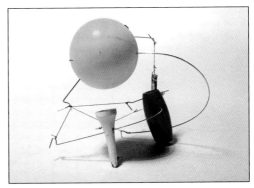

Fair

Abnormality > **Improvise** > Hybrids

Found objects

How do you define a found object? Is it a rejected bit of junk, a broken and forgotten item that is no longer wanted? Perhaps it is an item that has lost its appeal and is considered as being something from a previous age?

A found object might be some of these things, but really it's a story-teller. It is an emotional trigger for a previous time, capable of conjuring up memories and telling a story. It can build the necessary bridges with the past and the present. The found object is an item of fascination and intrigue, and provides an opportunity to pretend, play, and wonder. Manipulating a found object, holding and feeling it, and subjecting it to unfamiliar scenarios, private thoughts and experiments, enables simple, isolated ideas to be pondered. The found object has a wonderful past and much to offer. It does not need to be complicated. The found object is awaiting discovery and has a tale to tell.

How to...
What does something mean? Configure found, or a series of found objects into a physical montage, an abstract assembly of items that ignores convention to prompt an unexpected story; a story that might never have come to fruition without a physical nudge. The story can be explored, considered, rotated and tumbled to capture the imagination.

Modifications can be made, alternative and random items introduced, and the direction of the tale adjusted. The attaching of objects can be simple and unique, unfamiliar items can be brought together and configured to play off against each other. There are no rules in the configuration of a montage apart from that a story should be told and something understood – even if the message and meaning is often different to different observers.

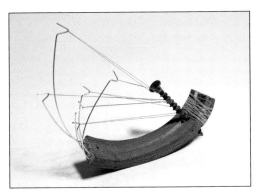

Breakup 1

Stage fright

LZ101

Silky

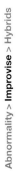

Wise but young

'Ad-lib' designs
'This process is as intuitive as I've found to date. It's a process of constant problem solving and what I believe to be a true design process.'
Matthias Pliessnig

Design
Matthias Pliessnig

Hybrids

Hybrids combine different elements to create an outcome that is usually unfamiliar, frequently unexpected, and always intriguing. The opportunity to introduce and mix physical and mental expressions, and to generate seemingly enhanced materials presents a broad range of possibilities.

Implied narrative

Interpretation of a hybrid is often directed at the unification, or merger, of opposing physical elements to produce outcomes that might reasonably be assumed beneficial. However, the objective of identifying an explicit advantage with such mongrel products isn't always sought, and opposing and contrasting narratives are occasionally encouraged to challenge perceptions and convention.

An implied narrative attached to a product can tease with plausible and counter emotions, requiring individual observers to interpret the message through personal association. Mental images that suggest different stories, arrangements that potentially conflict, or collectively enhance a message, can be as important as the physical artefact.

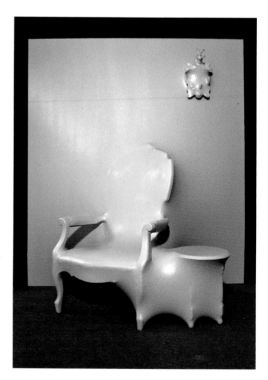

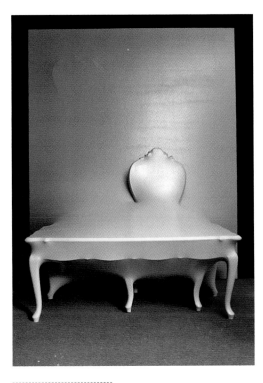

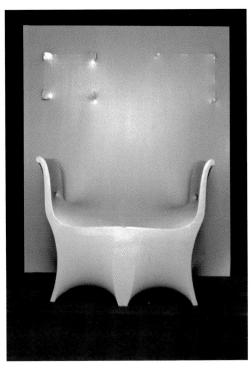

Parlour London (2002)
'These products have
been wrapped in an
elastic synthetic fibre.
The material shrinks
round a skeleton and
forms a smooth elastic
skin. The 'skeleton'
consists of existing
furniture, the elastic skin
gives it an entirely new
appearance. By cross-
breeding and grafting,
products and functions
of a different nature can
merge and develop into
new products.'
Studio Jurgen Bey

Design/photography
Studio Makkink & Bey

Studio Makkink & Bey
Architect Rianne Makkink
and designer Jurgen Bey,
along with their design
team, form the innovative
and highly creative
Studio Makkink & Bey.
Their narrative approach
to furniture and interiors
reflects a desire to
investigate, ask questions,
explore detail and
ensure that contexts are
considered and
understood. Studio
Makkink & Bey are
inspired by craftsmanship
and material selection;
this is evident in their
poetic collections, which
appear to evolve without
constraint.

Jurgen Bey graduated
from the internationally
acclaimed Design
Academy Eindhoven in
1989 and subsequently
worked alongside Jan
Konings as Konings + Bey
until 1998. He was also
involved with the Dutch
design group Droog from
the outset, where he
designed innovative
products such as the
'Tree-trunk bench'.
The formation of Studio
Makkink & Bey, with wife
Rianne Makkink, has seen
a continued development
of unorthodox and
thought-provoking
designs.

Conflict and harmony

Both conflict and harmony can be evident
in the numerous characteristics of products.
The relationships between different materials
utilised within a proposal are usually
considered carefully to ensure that different
elements relate and work well together.
However, there is plenty of evidence to show
that conscious attention is also given to
ensure that alliances or connections
deliberately clash or jar. Such manifestations,
which challenge convention and break or make
rules, are frequently regarded as invigorating
provided that the holistic design approach
receives similar care and attention.

A particularly interesting example of this
use of conflict in design came about when
Ettore Sottsass initiated the design group
Memphis in 1981. Sottsass defined Memphis
as the 'New International Style'. This style
embraced an eclectic range of aesthetic
influences and expressed anti-functional traits.

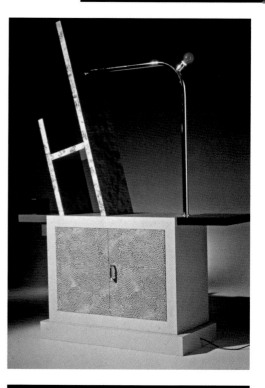

**Clockwise from top left:
Beverly Sideboard,
Carlton Room Divider
and Tahiti Lamp (1981)**
Examples of the 'New
International Style' with
its unusual and intriguing
combinations. The Carlton
Room Divider was
included in Maarten Baas'
'Where there's smoke...'
collection (see page 3).

Design
Ettore Sottsass
for Memphis

Memphis

The inspirational Ettore Sottsass instigated the design group Memphis in Milan in 1981, along with other designers including Michele De Lucchi, Marco Zanini, Martine Bedin, Aldo Cibic and Matteo Thun. The postmodernist manner of the Memphis group adopted a freethinking approach to design, an attitude that was able to rebuff the rules of modernism and eventually become a marker for design in the 1980s.

The contrasting styles that 'allowed' for the exploration of different characteristics (with seemingly unpopular, shocking, or unusual combinations) managed to break the stagnation in creativity that had been evolving. The ability to independently question the direction of design resulted in Memphis being internationally recognised and acclaimed.

Different

It is difficult to be different. This is not simply because of the physical challenges of finding an alternative, but has more to do with mental restrictions; knowing that something might be controversial if it deviates from the accepted path. However, speak to most designers and artists and they will probably say that they are trying to be different: aiming to identify a niche or break from tradition and to enjoy the experience of experimentation.

It is often only when an individual or group dares to be different that progress is actually made and that the boundaries are moved to accommodate the emerging perspective. When a suggestion or attitude becomes broadly accepted the creative individual will embark on a course that again strives to challenge and question the convention.

Experimental approaches

**Left: 'It's OK, He's Rich'
(2004)
Above:
'Loooossseeerrrrr'
(2005)**

A manipulated narrative
challenges a conventional
understanding of the
trite porcelain figures,
and suggests a more
contemporary alternative
meaning.

Design
Barnaby Barford

Barnaby Barford
The sculptures of artist
Barnaby Barford are able
to manipulate the
narrative of clichéd and
stereotypical figurines
through the reconfiguration
of form and language.

He metamorphoses
kitsch and banal figurines
into sculptures that
manage to embrace an
ominous reflection of
popular culture. These
sculptures capture the
imagination by continually
challenging an
established narrative.

Improvise > **Hybrids** > Cross discipline

Crossing disciplines and understanding what others do, how they do it, and why they do it, provides valuable information that can broaden horizons. The objective is not to copy what others do but rather to appreciate the alternatives and generate constructive dialogue. The search for cross-discipline approaches does not require random leaps of faith but simply to look around, understand; and then look further.

Rejuvenate

Hackneyed practices familiar in other fields are viable sources for inspiration and rejuvenation if they can be considered differently and out of context. An overworked material or method can readily transcend disciplines with impressive results. Seemingly trite or staid applications are awaiting the opportunity to be rediscovered.

Lace Fence by Demakersvan, with its wonderful contrasting characteristics, demonstrates just how fruitful this cross-discipline work can be as it stands in isolation from other, more mundane, approaches. The languages of crochet, knit and lace transform the product and enhance function, by merging aesthetic and practical attributes.

Demakersvan's creative approach shows that no design need be boring, harsh or dull if you apply thoughtfulness and affection. Design isn't about simply producing things; it is about enhancing the quality of life. Everything deserves careful attention.

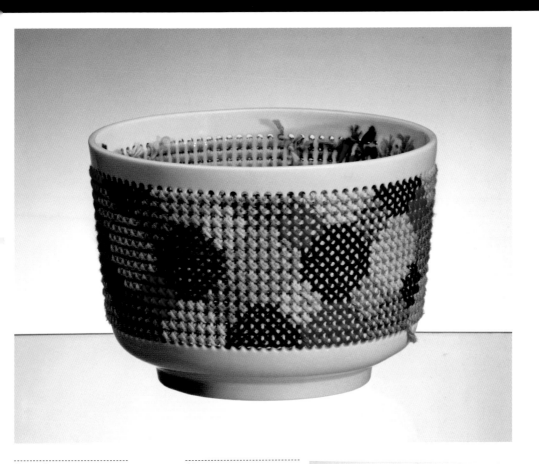

Opposite
Lace Fence
The harsh visual language
of fencing is transformed
by the adoption of a lace
configuration.

Design
Demakersvan

Photography
Raoul Kramer

Above
Panier Percé
Glazed white porcelain
with cotton embroidery
kit. Panier Percé is a
refreshing and stimulating
take on traditional
cross-stitch techniques.
The bowl is sold 'naked'
for users to decorate
themselves with the
accompanying
embroidery kit.

Design
Ionna Vautrin and
Guillaume Delvigne for
Industreal. Industreal
® all rights reserved.

Photography
Ilvio Gallo

industreal
panier percé

Jacquard 1
design & decor Vautrin & Delvigne

Hybrids > **Cross discipline**

Structure

A commitment to seeing things differently can achieve startling results and change perceptions. However, it takes a great deal of vision, confidence and nerve to initially introduce or place ideas in the limelight. Concerns about failure can have a detrimental impact on creativity and progress. The unfamiliar needs to be nurtured and encouraged during development and not readily abandoned. The comments of others should be taken on board but not necessarily allowed to sway a particular vision. To conceive and achieve an original and exciting outcome that is truly innovative and to be able to ignore mental baggage requires a level of commitment that many are unable to attain.

Accepting different methods, and not always being conservative in approach, enables the exciting to be realised. Occasionally, the transition from the accepted to the desired can be too much for a potential audience and therefore intermediate solutions need to be found that 'nudge' thinking.

The difficulty is acknowledging that things can be done differently. Just because you know how something is usually done does not mean it is the most suitable way. Alternatives that could improve on a particular direction are always waiting to be discovered.

A particularly strong example of this is the development of Spray-on Fabric by Dr Manel Torres. In this innovative approach to fashion design, non-woven fabric knits or weaves together as it comes into contact with the wearer's skin, forming a unique instant garment.

With his company, Fabrican Ltd, Dr Torres is now exploring even more exciting applications for this technology in the medical arena, with the potential for new types of patches, wound-healing products, dressings, and slow-release systems.

Dr Manel Torres
Dr Manel Torres investigated the efficient production of garments, aiming to identify a process that would be quicker than sewing or other labour-intensive approaches. Experiments with cotton fabrics that can be sprayed directly onto the skin to generate garments saw the idea transcend the disciplines of fashion and science.

Fashion has previously driven science with the development of such materials as Nylon and Lycra. As Dr Torres states: 'Fashion is often the trigger for science… from lab to catwalk'. The material has numerous other potential applications, which Dr Torres and his team are currently exploring.

www.fabricanltd.com

Experimental approaches

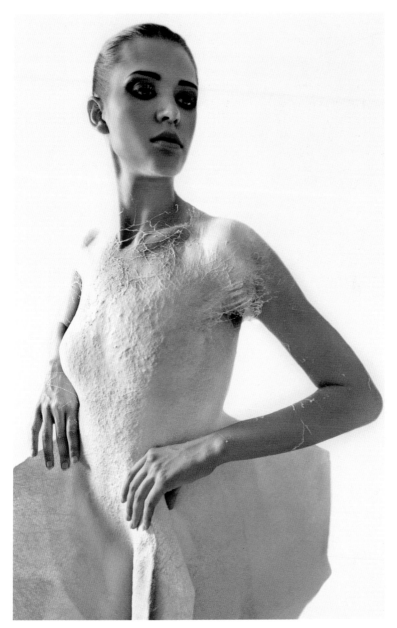

This page and overleaf
Spray-on Fabric
Fabric is sprayed directly
onto a model by the
sculptor/designer.
The immediacy of the
design, a result of intuitive
and inherent expression,
is individual and without
complication. The
acceptance of different
applications to explore
possibilities provides a
broad range of
opportunities.

Design
Dr Manel Torres

Photography
Gene Kiegel

Hybrids > **Cross discipline**

Sculpture

Sculpture can be realistic, symbolic, impressionist or abstract, but it will always seek to gain the attention of its audience. A sculpture can appeal or enthral through its composition, the deployment of materials or simply by being highly creative. Sculpture fascinates and poses questions to the observer and invites them to think and ponder for a moment, by telling its story.

The form of a sculpture is an intrinsic component in the message being communicated but it is not the only criterion to be considered and many other aesthetic and emotive qualities are also portrayed. Design has a strong relationship with sculpture and the two areas continue to fuse as the story to be told and the experience to be embraced become increasingly important.

The Dada movement (1916–1924) explored and questioned the language of things. Artists such as Marcel Duchamp (1887–1968) were able to see and categorise things from a unique and previously uncharted direction.

The ability to question convention and play with form, language, composition and materials meant that unfamiliar combinations were revealed. The found object became an important element attached to the art of the Dada movement. Rejected or overlooked items sometimes associated with banal or trite functions were transformed into artworks through a change in perception and perspective on the part of the viewer. The Dada movement eventually evolved into the surrealist movement and the questioning of meaning, story and language was taken even further.

Product design is becoming increasingly influenced by approaches more traditionally associated with sculpture; as evidenced by the seductive, emotive and alluring output of recent years.

Opposite and this page
Animal thing
The Horse lamp and Pig tray are part of the Animal thing collection, by Front, which combines fun with story, sculpture and design. The collection also includes the Rabbit lamp.

Animal thing was exhibited at the GARDEN exhibition at the Toyota Municipal Museum of Art, Japan, 2006.

Design
Front for Moooi

Photography
Anna Lönnerstam

Sculpture *n.* The art of making two- or three-dimensional representative or abstract forms, especially by carving stone or wood or by casting metal or plaster

Composition *n.* The nature of something's ingredients or constituents; the way in which a whole or mixture is made up

Hybrids > **Cross discipline**

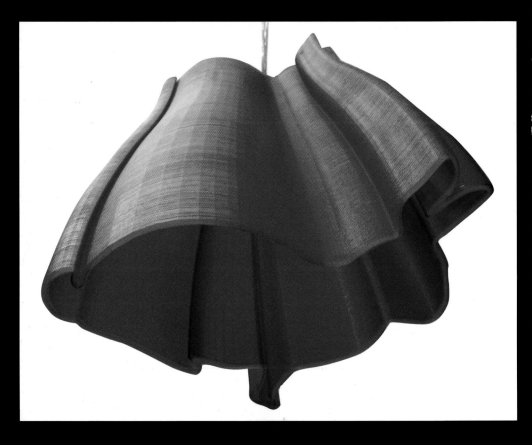

Bunny Lamp
The Bunny Lamp is
produced using
stereolithography, a
technique for creating
three-dimensional objects
in which a computer-
controlled moving laser
beam is used to build up
the required structure,
layer by layer, from a liquid
polymer that hardens on
contact with laser light.

Design
Marijn Vink,
Materialise.mgx collection

An 'instant act' is not an excuse to produce poor-quality or shoddy designs. 'Instant' is perhaps too often equated to 'rushed', an attribute that frequently bypasses quality and attention to detail to achieve an 'OK' reaction. Unfortunately 'OK' does not mean 'great' or 'fantastic' and 'OK' is not permissible. However, product designers use an array of quick methods to identify or rule out new directions. Some of the procedures produce beautiful inspirational answers to problems posed, while others, that are equally credible, appear to be nothing but an ephemeral collection of odds and ends.

Appearance and aesthetic qualities can be considered using simple instant acts, but if something looks ugly it should not be readily dismissed as it may still be making a valuable contribution. The culmination of multiple investigations informs and supports direction. The various exercises associated with instant acts are purposeful, meaningful, and informative and allow progression to subsequent design stages to be tackled with confidence.

Realising thoughts

It is possible to test a new idea, at a very elementary level, through the creation of a simple representation. Although usually primitive looking, basic models can still provide guidance and inspiration. There are no set rules for the generation of these primary physical triggers except that they should be explored and not ignored.

Ephemeral inspiration

Initial understanding of an identified thought is often realised in a momentary sketch model or maquette. Although different materials can be used or incorporated, including the formation of instant plaster concepts, it is most common for paper or card to be used in the first instance. The purpose is to examine the different possibilities that quickly emerge and to evaluate directions prior to further commitment. Although the controlled flexibility of paper and card is often a beneficial characteristic in the construction of such transient propositions, attention needs to be applied to accuracy, tolerance and detail.

If measurements are inaccurate or constraints not considered it is likely that any proposal will appear uncomfortable and awkward. It is necessary to work the material with significant care and awareness, appreciating that poor attention will almost certainly result in deformation and bias.

Modelling techniques
Many leading designers and organisations are embracing plaster-based modelling over more accustomed materials, as it helps them explore a more detailed and sculpted morphology in conjunction with flexibility of thought.

The paper-based laminated object manufacturing process is able to 'grow' paper forms through the continual attachment of identified layers. It is considered to be on the periphery between traditional and contemporary thinking on sketch modelling. The importance of efficient and faithful sensory feedback without compromise is the ultimate intention whatever method or material is selected.

'The first inspirational phase is the right place to try out ideas by making things, to use low resolution techniques, and to embrace failure.'

Bill Moggridge, IDEO

Left
Inanimate block model
Dutch designer Claartje Ketelaars created a range of minimal seating options after noticing local workers using slabs, bricks and rubble as improvised seating to avoid any direct contact with the ground. The block model pictured here is an experimental concept, constructed from laminated acrylic.

Design
Claartje Ketelaars

Photography
Clive McCarthy

Right
Card model
Card models are an effective and efficient way to communicate a basic idea. The geodesic dome is a form that can be constructed using a flat piece of card, although sculptural forms are often achieved more readily using alternative materials.

Photography
Clive McCarthy

Realising thoughts > Sophisticated simplicity

Consideration

Thoughts can be readily assessed through the prompt development of foam to explore physical and emotive responses. There are different foams, with different characteristics, available depending on the outcome required. For example, rigid polyurethane foam is often used where strength in a lightweight material is important during processing. The firm contruction of the material provides the opportunity for it to be subjected to a range of intimate and automated operations that are more akin to woodworking.

Polystyrene foam is also frequently used to produce quick, informal representatives of an idea and is available in a range of densities. Although sturdy, polystyrene foam is not usually capable of withstanding the same rigour as the rigid polyurethane, and is therefore usually manipulated by hand or with the use of a simple hot wire.

The production of formers to attain a required shape is an important aspect of foam modelling and needs to be considered carefully as any small mistake can swiftly quash potential. The creation of a former can be from an existing profile on a found object or it can be created using a strong and rigid material such as card or plywood in conjunction with abrasive paper.

Foam models are often left in their virginal state following construction, but can be dressed where necessary.

An intermediary form, in whatever guise, is simply a tool for achieving assurances and reaffirming theories. An inanimate block model is usually developed to form an impression of composition and, if possible, to appreciate user interaction, although any differences between the ideal and substitute material can present difficulties. The requirements of the product being represented will obviously impact on the materials employed and it may be necessary to utilise a more substantial material or perhaps a found object to clarify or endorse a specific area.

In contrast to block models, which usually do not include any moving components, an animate model will try to faithfully demonstrate certain features that may ultimately be present. Despite managing to stimulate interest the model is not usually a sophisticated output, but simply an instrument that assists in the context of ongoing thoughts. It remains a preliminary suggestion, at the mercy of the creator and capable of adjustment or rejection.

Validity rigs are used to understand a particular situation more clearly and although they can be produced at a scale that differs from the proposed solution in order to accommodate theory, they are more likely to conform as closely as possible to an intended proposal. A validity rig is usually functional in a mechanistic manner, aimed at understanding principles and often pushing limits until destruction. It is unlikely that such a rig would endorse any aesthetic qualities unless emotive judgements are being sought.

How to...
To make the most of these improvised representations simply requires an open mind and acceptance that something so basic can be a very beneficial critical tool.
Representative items with the general characteristics of the predicted product can be found anywhere and everywhere and should be collected or considered in their natural environment.

It is important not to be overly fussy, but still try to secure a reasonable resemblance. Assembly of sourced components should be as honest as is reasonably possible, but not necessarily beautiful. The completed item can be critically appraised. If the exercise is done effectively it supports progression, but if it is badly executed steps will probably need to be retraced sooner rather than later.

Former *n*. A tool, mould, or other device used to form articles or shape materials

Validity *n*. Actually supporting the intended point or claim

Realising thoughts > Sophisticated simplicity

'For the spheres the surfaces are sculpted to appear random and handmade pushing limits of both machine and decoration. The intention was to illuminate the material through an explosion of energy and light – as if the energy is burning through the material, whilst constantly being patched over.'

Christopher Coombes, Industreal

Verification

The function of a model is to allow the designer to critically appraise aesthetics prior to any decisive commitments and therefore construction should be executed with particular vigilance. At the point of fruition a judgemental view can be instantaneous. A cursory inspection will reveal if any malignant thoughts have entered and betrayed the overall process. Verification of an idea is not only subject to physical testing but mental associations or perceptions can be equally damaging. Unfortunately, it is usually not a simple process to eradicate anomalies with superficial or cosmetic adjustments.

If the proposal is found not to be viable, a reflective attitude may discover what's wrong and fix it by making more rudimentary investigations at the outset or just considering alternative methods for effective production.

Prototype *n*. A first or preliminary form from which other forms are developed or copied

Counterbalance *n*. A weight that balances another weight

Cristiana Giopato and Christopher Coombes
In 2004, in conjunction with Tomas Ortiz-Ferrer and Guillaume Delvigne, Cristiana Giopato and Christopher Coombes were instrumental in coordinating the adventurous 'In Dust We Trust' exhibition. The event promoted the manufacture of 'immediate objects' and bypassing secondary manufacturing by using rapid prototyping strategies.

The 'In Dust We Trust' showcase of beautiful and challenging work was the result of a carefully assembled group of young and dynamic designers. The facilities of Oneoff were utilised in the production of the collection, which resulted in the development of design group Industreal.

Instant acts

Personalised

The production of a unique prototype piece to consider if everything is in order and properly considered is usually undertaken prior to engaging in a mass-production process. However, one-off individuality is increasingly popular and consumers frequently require an individual, personalised aesthetic that is coupled with mass-production. Evidence to show that consumers want to personalise their wares is abundant and production methods are becoming increasingly responsive. The capacity to create 'mass-produced one-off' products is evolving, a situation where consumers interact at pre-production stages rather than modify outputs at post-production.

The boundaries and philosophy of the maker craftsman and the product /industrial designer are merging as understanding of good and necessary practices in both camps are recognised and appreciated. The prototype can be regarded as the culmination of ideas leading to production of identical artefacts, but it can also be considered to be a springboard that launches the ideas process especially as discipline identities continue to fuse.

No Pully
'No Pully' is part of the Industreal 'In Dust We Trust' collection and was produced in plaster using rapid prototyping techniques.

Design
Cristiana Giopato & Christopher Coombes. Industreal ® all rights reserved.
www.industreal.it

Photography
Ilvio Gallo

Realising thoughts > Sophisticated simplicity

Complex and delicate

Designers are adept at embracing opportunities and seeking to gain familiarity with an area that demonstrates potential. This inquisitiveness has seen rapid prototyping used to tackle an eclectic range of sculptural and often organically inspired products. It has been particularly successful in lighting projects as the process lends itself to the creation of complex and delicate items, and the translucency of the materials used allows for the exploitation of light and shadow. This ability to sensitively duplicate a natural aesthetic and also fabricate intricate diffusers that obscure or direct light, would be hard to achieve using any other method.

This was particularly apparent at the 'In Dust We Trust' exhibition as Christopher Coombes remembers: 'Prototypes are beautiful, immediate, delicate representations of the development of an idea that often get twisted by commercial and industrial constraints.

'So the objective of the exhibition was to inject soul and dignity into this manufacturing process by creating real objects with long-lasting purpose that encapsulate the mysterious origin of an idea. Designers were invited to consider the material properties without using secondary processes. This promoted three fundamentals – to unify the collection through the rough unfinished sculpture-like surfaces, to experiment [with] a possible industrialisation, and to encourage extreme form and functional research, aided by workshops.'

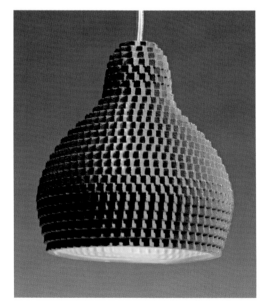

**Lampe 72 dpi (left),
Lampe 144 dpi (middle)
and Lampe 300 dpi
(right) (2004)**
The lamps are produced
in black unglazed
porcelain and are part of
the Industreal 'In Dust We
Trust' collection. The
collection demonstrated
the versatility and
potential of achieving
sophisticated outputs with
a controlled input. The
surface textures represent
72 dpi, 144 dpi and 300
dpi respectively.

Design
Guillaume Delvigne,
Industreal ® all rights
reserved
www.industreal.it

Photography
Ilvio Gallo

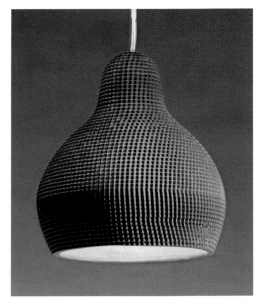
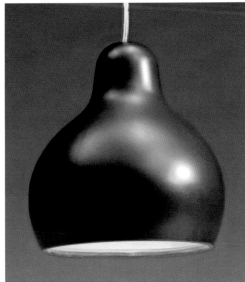

Realising thoughts > Sophisticated simplicity

Sophisticated simplicity

The development of a product requires careful management to ensure that all elements function properly. Many designers try to simplify this process by breaking it down into lots of small stages. Ironically, this can actually introduce unnecessary practices that complicate things; it is far more effective to reduce the number of stages. A design system where the product remains sophisticated and simple is best for the designer, producer and end user.

Originality

Rapid prototyping processes can give the impression of the product growing or being born, as the designer can watch the idea evolve into a complex constructed form. The process is relatively simple, but it can produce awe-inspiring results with forms that might simply be inconceivable using other processes. The wonder of processes such as stereolithography and selected sintering is that outputs are generated swiftly and can be subjected to change without significant interruption or difficulty.

There is no need for products to be identical. Why should they be? Every item can be original. However, to achieve this originality means questioning the traditional design approach and challenging cumbersome logistics on all fronts. The flexibility of rapid prototyping processes presents significant opportunities to increase personalisation and interaction, as well as affording an opportunity to respond immediately to fluctuations in markets. Indeed, some products do not even need to be manufactured until they are actually required by the customer.

Oxymoron *n.*
An expressed idea in which apparently contradictory terms appear in conjunction

Grow *v.* Undergo natural development by increasing in size and changing physically

Rapid prototyping (RP)
Rapid prototyping (RP) or additive layer manufacturing is a method used to effectively and efficiently construct 3D objects through the build-up of numerous cross-sectional slices.

The information to produce the physical artefacts is taken from 3D digital models and is often referred to as growing or printing a model. A burgeoning range of materials exist for the process including wax, paper, polymeric materials, and ceramic and metallic powders.

Sinter *v.* Make (a powdered material) coalesce in a solid or porous mass by heating it (and usually also compressing it) without liquefaction

1957
The light's outward spiral embodies a complex mathematical sequence evident in nature known as 'Fibonacci numbers'. The dome-shaped light is grown using laser-sintered polyamide.

Design/photography
Janne Kyttänen,
Freedom of Creation

Freedom of Creation
Freedom of Creation (FoC) was formed in 2000 and is located in Helsinki. Designer and creative director, Janne Kyttänen, is a member of a team that specialises in the connection between research, design and future technology.

The logistical benefits of rapid manufacturing are a central theme to the activities of FoC, an approach that has seen an impressive range of thoughts and ideas come to life. Freedom of Creation BV in Amsterdam was founded in 2006.

Inspired by nature

Designers, artists, and craftsmen have always looked towards nature for inspiration. Sometimes this has meant harnessing natural materials to embody an idea, or attempting to replicate the wonders of the natural world, but it has also frequently meant striving to achieve the poetic language and aesthetic elegance of nature.

Simulation

Throughout history, the functional approaches of nature have been simulated by architects and designers using representative approaches and morphologies. In recent times, however, designers have been able to take this a step further with products that can be artificially 'grown' using laser-sintered polyamides. These can be used to create the most organic and complex configurations using inanimate materials, such as these wonderful designs by Janne Kyttänen at Freedom of Creation.

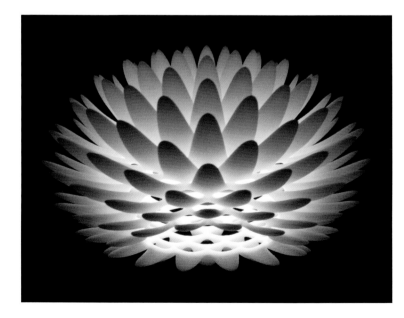

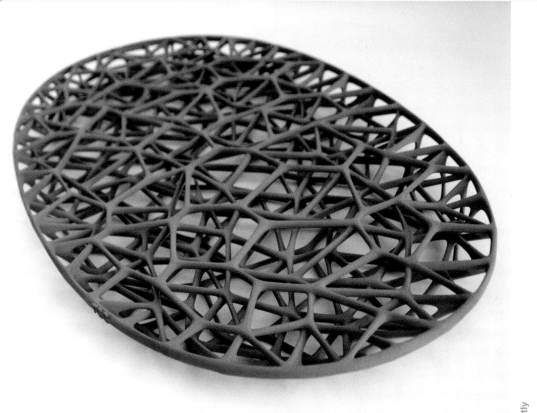

Left
Palm light (2006)
The light is inspired by
graceful, flowing foliage
that permits diffused light
to escape. The light is
grown using laser-sintered
polyamide.

Design/photography
Janne Kyttänen,
Freedom of Creation

Above
The Trabecula tray (2007)
This complicated
structure, inspired by soft,
low-density Trabecula
bone, is grown by
laser-sintered polyamide.

Design/photography
Janne Kyttänen,
Freedom of Creation

Sophisticated simplicity > **Inspired by nature** > Seeing things differently

'The design exploits additive manufacturing technology to the full
with complex internal passageways and a wafer thin translucent skin.'

Lionel T. Dean

Chaos

The inspirational Chaos
lamp is part of the
Materialise.MGX
collection, designed by
Danish design studio
Strand + Hvass, and was
grown using laser-sintered
polyamide.

Design
Strand + Hvass

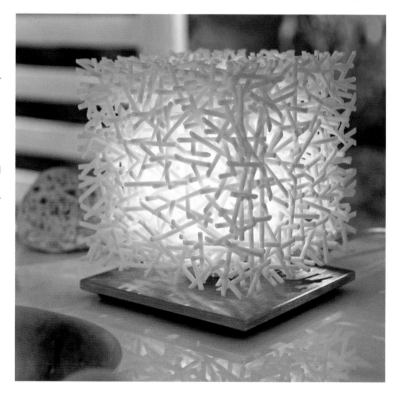

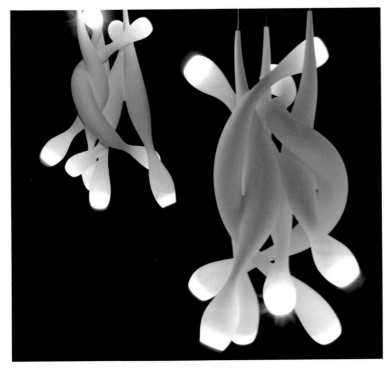

Tuber9 (2004)
Tuber9 is a sophisticated
development of the 2003
Tuber Pendant Luminaire.
The Museum of Modern
Art in New York acquired
Tuber9 for the permanent
design collection in 2005,
and, in 2008, identified
it as one of the most
significant additions to the
collection since 1980.

Design
Lionel T. Dean
for FutureFactories

Tangle floor lamp (2005)
An intricate and carefully
compiled assembly of
delicate diffusers gently
shrouds the inner halogen
light source. The beautiful
Tangle lamp is grown
using laser-sintered nylon.

Design
Lionel T. Dean
for FutureFactories

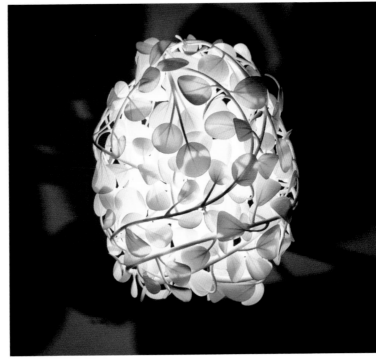

Sophisticated simplicity > **Inspired by nature** > Seeing things differently

What defines a product? Is it the material, the process, the philosophy, the approach, or is it all of these attributes plus an elusive 'something else'? It is difficult to define what a product might encompass and with every original idea that is processed the boundaries appear to shift. Designers therefore need to constantly be on the look-out for new ways to see the world and how their designs might contribute to it.

Food for thought

To help keep their thinking open and flexible, many leading designers have spent brief periods experimenting with disciplines outside of their traditional remit. In this way, architects have designed products, product designers have designed buildings, and automotive designers have even designed pasta. These short sojourns into new territories help introduce fresh thinking and can even open up new insights into the designer's more traditional arena. The nature of thinking does not necessarily change because of the creative discipline an individual decides to engage in, and so buildings, products and foodstuffs can all be subjected to a similar interrogation. A particularly charming example of this comes from the innovative and original thinkers at design consultancy IDEO, who explored ideas relating to chocolate and revealed an exciting range of possibilities. The proposals, a reflection of astute observations, recognised that desire and ceremonial play were important considerations.

IDEO chocolates

1. Removing the top of a chocolate provides an opportunity to view the filling.

2. A decision can be made to eat the complete bundle or individual sticks.

3. 'Love me, love me not.' The petals are removed to reveal the inner filling.

4. Chocolate that can be placed on the end of a finger to eat, or paint with!

5. The chocolate can be enjoyed before the filling.

6. A corn-starched top containing brandy can be stirred in coffee to release the liqueur.

7. Chocolates that can be played with before eating them.

8. A chocolate construction kit where the various parts can be licked before joining.

9. The chocolate pill for those that do not like the taste of chocolate.

Design
IDEO

1

2

3

4

5

6

7

8

9

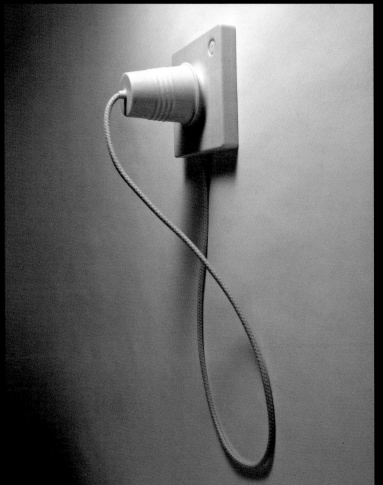

Allo?! (2005)
Allo?! is an entryphone
inspired by the 'cup and
string' phone played with
by children all over the
world. It is part of the
successful Industreal
'Model Ideas' collection.
The playful and
memorable product is
constructed in plaster
using rapid prototyping
technology.

Design
Guillaume Delvigne and
Ionna Vautrin. Industreal
® all rights reserved.
www.industreal.it

Photography
Ilvio Gallo

In thinking about how something could be done it is important to know if it has already been achieved in some other capacity and to reflect on any previous experiences that might be considered to be analogous. It is not uncommon for things to have been encountered previously, but because it might be in an unfamiliar context it is not always possible to recall or appreciate. To question if something can be done requires the identification of a particular thought, something that can be prompted by a trigger at the start of a journey, or maybe something at the end of a previous encounter that reveals itself. Whatever the situation, arriving at the question, 'can it be done?' is, in itself, an innovative step.

In an attempt to achieve an answer, literal and lateral approaches should be used to ensure things are viewed creatively. Further questions need to emerge and should be tackled with a similar understanding.

There are a wide variety of physical resources that are at the disposal of the product designer and many are well documented. International museums and galleries with exceptional reputations are obviously a source of significant inspiration and information, but accessibility can sometimes be a difficulty and alternative strategies are everywhere for those who care to look.

There are many types of research centre, some perhaps more obvious than others. A literal and lateral approach to collecting information and being inspired reveals that an array of centres continually surrounds us. The most obvious centres such as galleries, museums and libraries can be used alongside personal experiences and findings.

Everywhere

The actual walk to a museum or gallery can offer as many inspirational cultural insights and references as the intended collection. A range of exciting possibilities and opportunities exists along the way, but they are too frequently overlooked because they are considered unimportant. These 'raw collections', street items and details that can inspire and direct, surround everyone and are constantly available for viewing. Looking, rather than seeing, can undoubtedly unlock their potential and unleash a chain of thoughts. These raw collections often need work, special attention and consideration by an individual to identify, tame and understand them, but once a designer is attuned to the possibilities everything excites and has something to offer.

Maybe a detail or contrasting elements capture the attention, or perhaps a peculiar construction or relationship is observed. The more you look the more you see. The raw collections are often set out irrationally, and can appear as a confused and chaotic assembly of triggers. Continually moving, they constantly await discovery and the recognition they deserve.

Formal collections that have been removed from their natural habitat can occasionally appear sterile because cohesion between product and surrounding is reduced or absent. Sensory stimulants can recall memories and emotions, but their absence almost certainly impacts on the imagination and the ability to make valuable connections.

Although raw collections on the street, cultural diversity and historical references can contribute effectively to ongoing thoughts, the formal collections at a museum or gallery should still be frequently explored. The subject matter may not always be important, as it is the continual ability to extract sensory information that is necessary and this can be found in everything by looking, feeling, and absorbing an experience.

The seemingly dull should not be ignored, as there is always something to be found that will inspire a curious mind, although it is not always obvious. The methods and approaches to materials used by unfamiliar cultures or ancient predecessors can conjure up suggestions that would almost certainly not be considered otherwise. Diverse inputs and thoughts can be shuffled and recorded to transcend the generations and create exciting outcomes.

New York City street
A walk along a street reveals numerous collections, in their original surroundings and in an appropriate condition. The ability to actually look and really appreciate surroundings in everyday situations provides a considerable amount of information, which often goes by unnoticed or is quickly forgotten. It is often the case that things are taken for granted and that individuals become blind to important information because it appears so frequently. Valuable collections are everywhere and should be acknowledged.

Photography
Tim Harrison

How to...
Observe everyday activities with an open mind and try to extract a particular facet from the encounter. Look at the physical relationships between objects and trust your instincts to decide if something appears right or not. If something seems to grate, question whether it is wrong or if the contrast intrigues and fascinates. Were the rules broken and why?

If something appears uninspiring try to identify a single aspect that can prompt more imaginative ideas. Consider the standard methods of production alongside alternative processes that could influence the development. Continually be on the look-out for an original thought and not simply a facsimile of something that's already been produced.

Exhibitions

Attending an international design exhibition such as 'New Designers' or '100% Design' (London), 'Greenhouse' (Stockholm), or 'SaloneSatellite' (Milan) is an opportunity to gather an immense amount of information, understand current trends, and also confirm your instincts, feelings and thinking. Such events allow and encourage a cultural sharing of ideas and thoughts, and often signify the instigation or rejection of a trend.

Influence

Opportunities to ask questions and engage in meaningful dialogue about practical and philosophical aspects of design are abundant. The senses are allowed to run riot, as triggers are continually stimulated. Visual statements are constantly invited and unconscious thoughts are prompted to emerge. Methods of production are frequently challenged and configurations, which may not have been considered plausible, are allowed to take centre stage. Exhibitions are theatre, a visual swatch that attracts and compels, and a performance that relays a myriad of contrasting messages.

The items that are exhibited are of primary importance, but to look around and absorb the peripheral considerations is also creatively beneficial. Compositions and moods that are generated act as secondary triggers and reinforce the predominant visual accents. To explore, wander, and keep an open mind, striking up conversations with the designers, makers and producers, feeds an important mental catalogue. All the experiences and references that are encountered will almost certainly be resurrected in some capacity in the future and be deemed invaluable.

SaloneSatellite

570 young designers and 22 international design schools with 220 students showcased ideas and projects inspired by creativity, ecology and sustainability at the 2008 SaloneSatellite exhibition.

Organisation

The execution of an exhibition requires considered organisation, planning and a realistic appreciation of time. An exhibition is a showcase and as such needs to be of a standard that is both professional and appropriate for the items being presented. The exhibition may be on the international stage, but can also be a private affair, something that is going to be viewed by a select audience. Whatever the scenario, the fundamental aspect is that it enhances the predominant message.

There are numerous ways to conduct an exhibition, but perhaps the most common is to reproduce the atmosphere of a gallery. International companies build elaborate and fantastic environments, but they also manage to retain the clean and simple feel of a contemporary space.

A layout for an exhibition needs to be addressed like any other design problem. Options need to be considered, constraints need to be challenged or accommodated and the deadlines need to be met. An exhibition setting should aim to complement the work rather than dictating the mood, so restraint needs to be shown in how the supporting elements are designed and utilised. Consideration also needs to be given to elements such as lighting, movement, storage, maintenance, security and safety.

The transit of items to and from an exhibition requires significant preparation, and thought needs to be given to insurance and the packaging of artefacts.

An exhibition is not a minor undertaking and certainly requires a lot of planning and forethought. It is a complicated mix of tasks, each needing to be identified and conducted at the appropriate stage.

In the organisation of any substantial event, problems should be expected and contingency plans put in place to ensure suitable alternative options are available.

Can it be done?

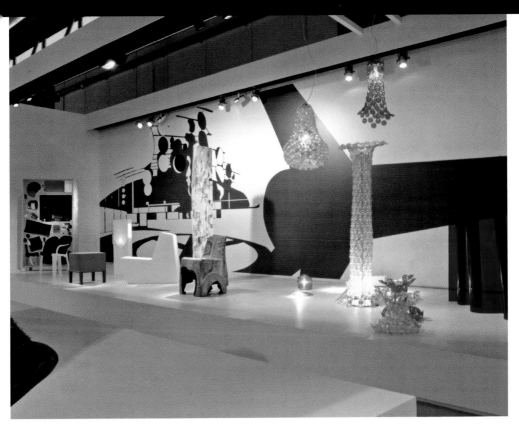

How to...

Substantial planning of an exhibition needs to be conducted prior to any formal involvement. An awareness of standards and restrictions needs to be comprehensively understood. Primary and secondary research must be conducted. Attending exhibitions to obtain a thorough understanding of standards and control is critical to gain a feel for the process.

Trawling through journals and press reports will also provide an overview of what is required, and important information about the kinds of visitors likely to attend. Skimping on background research prior to an exhibition is almost certainly going to be detrimental on all fronts and could jeopardise any future opportunities. There is usually only one chance to get it right and the process must not be left to chance. Research every detail and then do it again.

It is not always the most famous or familiar collections that deliver inspiration; specialist and regional museums can also provide a necessary imaginative trigger. Although there is no doubt that the international museums in design are essential, visiting smaller seemingly less significant collections is also a very valuable activity.

Dialogue

A resource centre should not be considered as an inanimate entity, something that is only attended in order to gain an understanding and appreciation of what has gone before. Rather, they should be considered guardians of knowledge, which can assist in the direction and formulation of future projects. A resource centre can be considered an animate institution, as the individuals there are a valuable source of information and talking is perhaps the most effective way to understand and appreciate the history of design. Indeed as every individual has an inherent ability to interpret information, anybody could be considered a 'resource centre'; made up of anecdotes, experiences, and perspectives that are unique to them.

In this sense, producers are particularly valuable research centres, where understanding and a reasonably balanced perspective can be sought. Dialogue with producers, to provoke debate and question possibilities, is a beneficial activity and it is just as important to consider what could be done in the future as it is to reflect and understand what has been done in the past.

International Museums of Art and Design

Center Georges Pompidou
Paris, France
www.centrepompidou.fr

Centraal Museum
Utrecht, Netherlands
www.centraalmuseum.nl

Cooper-Hewitt National Design Museum
New York, USA
www.cooperhewitt.org

Design Museum
London, England:
www.designmuseum.org

Design Museum Gent
Gent, Belgium
http://design.museum.gent.be

Guggenheim Museum
New York, USA/Bilbao, Spain/Venice,
Italy/Berlin, Germany
www.guggenheim.org

Kunstindustrimuseet
(Danish Museum of Art & Design)
Copenhagen, Denmark
www.kunstindustrimuseet.dk

Kunstindustrimuseet
(Norwegian Museum of Art & Design)
Oslo, Norway
www.kunstindustrimuseet.no

Metropolitan Museum of Art
New York, USA
www.metmuseum.org

MOMAK The National Museum of Fine Arts
Kyoto, Japan
www.momak.go.jp

The Montreal Museum of Fine Arts
Montreal, Quebec, Canada
www.mbam.qc.ca

Musée des Arts Décoratifs
(Museum of Decorative Arts)
Paris, France
www.lesartsdecoratifs.fr

Museum für Angewandte Kunst
(The Museum of Applied Arts)
Frankfurt, Germany
www.angewandtekunst-frankfurt.de

Museum für Gestaltung
(Museum of Design)
Zurich, Switzerland
www.museum-gestaltung.ch

Museum of Modern Art
New York, USA
www.moma.org

Powerhouse Museum
Sydney, Australia
www.powerhousemuseum.com

Röhsska Museet
(Museum of Design and Applied Art)
Gothenburg, Sweden
www.designmuseum.se

Design Museo
(Design Museum)
Helsinki, Finland
www.designmuseum.fi

Tate Britain/Tate Modern
www.tate.org.uk

Tel Aviv Museum of Art
Tel Aviv, Israel
www.tamuseum.com

La Triennale di Milano
Milan, Italy
www.triennale.it

Victoria & Albert Museum
London, England
www.vam.ac.uk

Vitra Design Museum
Weil am Rhein, Germany
www.design-museum.de

Whitney Museum of American Art
New York, USA
www.whitney.org

The Wolfsonian – Florida International University
Florida, USA
www.wolfsonian.org

Material libraries

Material libraries are an excellent resource and can provide information that may otherwise be impossible to track down. They can be found either attached to manufacturers or as an independent facility.

Unaccustomed thought

Material research needs to be presented and allowed to enter the public domain. Experiments are continually conducted with materials, to identify special or unknown properties, with the aim of attracting a broader audience. The outcomes of such experiments are sometimes planned, having followed a prescribed methodology, but frequently the results are unexpected and can prompt an interesting thought or opportunity. These fascinating outcomes can be found in a variety of places including the specialist material library.

To marvel at the seductive and alluring selection of materials available at an internationally recognised materials library can sometimes be bewildering but is always intriguing. The materials with their extraordinary, and often unfathomable, qualities entice the imagination and often demonstrate the capacity to sidestep conventions and ignore rules and boundaries. Transparent concrete is one example of the unusual materials that can make an observer question the boundaries of possibility.

A sense of innocence frequently surrounds new materials with as yet uncertain applications, and it is easy to be led astray with irrational thinking and romantic visions when subjected to their persuasive characteristics and traits. The materials can unsettle and distract logical thinking, but their ability to stimulate, rouse, and entertain abstract thoughts reflects the attention that these 'adolescents' demand.

They cannot be ignored or overlooked, they cannot be forgotten, and they cannot be dictated to. Their original make-up appeals to different individuals and the fate of their application is to be discovered and announced. There are few, if any, precedents to suggest or direct intentions. Exposure to the unknown and the unfamiliar provides opportunities to play and enjoy the relationship, although traditional materials should not be ignored during the adventure.

Suggestive thought

Libraries or exhibitions of exceptional materials in a particular field can often be accessed at the point of manufacture or production. Unprecedented approaches, and ingenious practices, the result of extensive research strategies, are normally presented to entice designers to subscribe and sanction a particular material or method. The information frequently reflects, or sets, contemporary standards and usually manages to surprise and even amaze with what is actually possible. Although such exhibitions tend to promote a specific material it is not uncommon for concepts to communicate what could be 'if only'. The 'if only' material proposals suggest a particular market direction and seek endorsement to kick-start a line of thinking that engages the targeted audience. Such materials can turn a market place and succeed in revolutionising the way that something is done or viewed. Many emerging materials have stolen identities; characteristics that might be expected to belong elsewhere and in another family.

Material ConneXion
The Material ConneXion library in New York is a seductive and inspirational resource that presents innovative and emerging material information.

Alternative sources > **Material libraries** > Projects

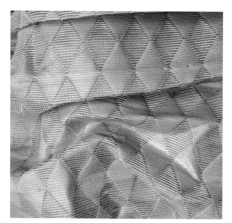

Japanese wood fabric with silk

Crystal fabric

Smash: a non-woven fabric

Material ConneXion
The Material ConneXion
library attracts global
organisations and
companies, but also
appeals to the individual.
The diversity of the
materials almost defies
belief and continually
stimulates the
imagination through
physical interaction
and clarity.

Design
Material ConneXion,

Material ConneXion
Material ConneXion
is the foremost material
resource organisation
that supports industry,
research and education
with material information,
solutions and innovation.
A network of
multidisciplinary
consultants around the
globe, combined with
physical and virtual
resources; ensures that
Material ConneXion
retains its authoritative
presence for material
options. www.
materialconnexion.com

Can it be done?

TEPEO2 ® (compact and foam foils)

Holoknit textile

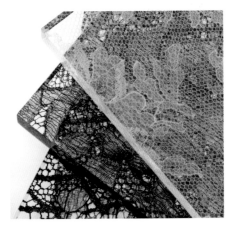

Fabric in acrylic

Tegris

Koshi

Gel cushion

Alternative sources > **Material libraries** > Projects

Random things

The practice of continually collecting and hoarding artefacts that intrigue and offer something of interest can become a convenient resource when initially considering materials for a particular application. The random objects, with their disparate make-up and heterogeneous characteristics, provide an insight into previous directions and thoughts, offering inspiration and assistance in locating a basic genre of materials; a private starting point without hassle or pressure.

It is not essential to immediately comprehend composition – indeed it may be counter-productive as mental baggage can be a barrier to creativity – but it is essential to simply identify a possible pathway to explore. A rudimentary assessment can be conducted through looking and feeling the collected products to decipher what stimulates and arouses any interest. Such initial stages can afford to be selection by association rather than confirmation, as the journey may ultimately reveal a previously unknown option.

An artefact or combination of objects with similar traits to those that are sought is usually more beneficial than a vague verbal description of what is desired. Physical referencing of objects enables a more focused investigation to be conducted and subsequently reveals suitable options that may possibly become fit for purpose.

The peculiar and often obscure acquisitions in creative landscape are in essence a primary resource; a simple and necessary set of triggers for future development.

The following terms could be associated to the different items and inspire thinking and direction:

Gun holster > Detail; Features

Milk bottle > Practical; Pragmatic

Paper fan > Simplicity; Transparent

Toy soldier > Cheap; Tawdry

Ice hockey mask > Threatening; Intimidate

1000W bulb > Elegance; Fascination

Brownie camera > Textural; Balance

Shaving mirror > Purity; Sterile

Snorkel > Softness; Malleable

Baseball bat > Strength; Power

Frying pan > Robust; Hardy

Rubber duck > Fun; Play

Leather football > Quality; Trait

Tinted swimming goggles > Contrast; Variances

Coloured Frisbee > Exciting; Thrilling

Sand castle bucket > Entertaining; Action

Life jacket > Serious; Clarity

Vanity case > Trashy; Garish

Make-up brush > Sensitive; Caring

Bowler hat > Important; Formal

Porcelain figurine > Trite; Tasteful

Plastic chopsticks > Imitation; Effective

Antique monocle > Cultural; Ostentatious

Cuckoo clock > Ugly; Banal

Silver hip flask > Respectful; Patina

Tinsel pompoms > Excitement; Wild

Pink ski boot > Safe; Harm

Rubber flipper > Different; Repellent

Welding mask > Harsh; Angry

Stethoscope > Trusting; Precise

Test tube > Functional; Delicate

Candy coloured music box > Individual; Weak

Silk ballet shoe > Pure; Light

Plastic action figure > Manipulation; Joints

Gold plastic souvenir > Brash; Crass

Silver candlestick > Sophistication; Luxury

Transparent umbrella > Protective; Enjoyment

Antique locket > Sentimental; Story

Charm bracelet > Emotional; Memory

Gold plated pocket watch > Cultural; Substitute

Tortoiseshell hairbrush > Impersonation; Combinations

Violin > Beauty; Emotional

Silver ticket clock > Fascination; Ingenious

Tweezers > Efficiency; Exact

Metal mousetrap > Dangerous; Relentless

Hockey stick > Strength; Tribe

Pearl drop earring > Delicate; Wealth

Leather purse > Crafted; Texture

War medals > Meaningful; Narrative

Spray gun > Functional; Polish

White riding gloves > Quality; Meaning

Collapsible top hat > Impressive; Sheen

Lace cloth > Fragile; Gentle

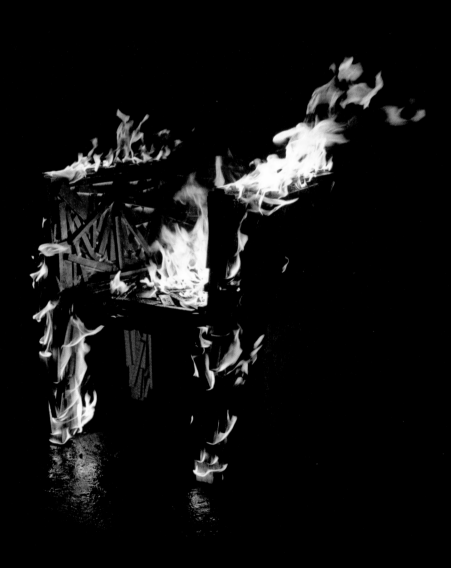

The need to explore and question is a necessary part of the overall design process. To try out approaches and engage in unfamiliar actions provides an opportunity to grow and develop new ways of thinking. It is important to set aside time to indulge your curiosity and experiment outside your comfort zone.

The following projects are aimed at introducing different approaches to help you think laterally and engage in unfamiliar design practices. Constraints are utilised within some of the assignments to focus the journey without stifling creativity.

The Favela Chair: Smoke Collection (2003–2004)
The Favela Chair is set alight and becomes part of the 'Where There's Smoke....' series designed by Maarten Baas, for Moss, New York, 2004. The project involved works by internationally renowned designers being set alight; transforming the visual and emotional language of the pieces. The charred remnants, preserved with epoxy resin, are now featured in international design collections.

Design
Maarten Baas

Photography
Bas Princen

- - - - - - - - - - - - - - - - - - - - - - - - - - - - - - - -

Project 1
10 chairs

Source a standard wooden or plastic chair
and consider the function and purpose of the
selected item. How else could it be used?

Manoeuvre the chair into 10 unfamiliar
arrangements and situations, and consider
what it could represent. It may be necessary
to add further chairs, or to add additional
components; however the starting point
should be the original chair that was identified.
Avoid any modification of the actual chair,
which should be clearly identifiable within
any outcome.

- - - - - - - - - - - - - - - -

Project 2
Reconfiguration

The composition of everyday items frequently
have a well-established form made up of
familiar components. Any investigation into
revising this kind of very familiar item should
always ask the fundamental question: 'why is it
made this way?'. Being innovative may require
a risk to be taken, but it can also be dangerous
to be blinkered to new thoughts and ideas.
Failure is not necessarily a bad thing, but rather
an experience to build upon and move forward
with. To be mundane and dull is more akin to
failure, failure without purpose.

Identify an everyday product (such as a
clothes peg or CD holder) and collect a broad
range of examples, including any analogous
items, i.e. those that share similar traits. Using
the different elements design a range of
products 'descended' from the sourced items.
It is unlikely that the emerging, mutant
generation of products will appear beautiful,
but the range should aim to question the
accepted design principles for that product
and offer something different that can be
explored further.

- - - - - - - - - - - - - - - -

Project 3
Paper play

Simply manipulating a strip of paper and feeling its characteristics is an intuitive process. The action of bending, flexing, twisting, turning and generally encouraging the paper to respond to impromptu decisions can generate a multitude of ideas, which are often revealed and lost in an instant. Decisions are encouraged and rejected in a seemingly subconscious state, as any thinking tends to be conducted at a post-realisation stage. The continual working of the paper will eventually reveal familiar morphologies, structures that continually return and present themselves.

Identify the different languages that are communicated by a paper strip and look to use the information as a basis to inform the development of a range of products.

Project 4
Emotive morphologies

Instinctive emotions such as happiness, anger, and sadness are intense feelings that can be triggered by a variety of stimuli. A product has an emotional function as well as a physical function and both require careful consideration and development.

Instigate a series of small sculptures that explore different emotional states in an uncomplicated, lateral fashion. The different forms should be subtle experiments, using found objects, that aim to capture the essence of an identified emotion within a completed assembly, rather than incorporating any individual element that would be capable of exploiting a particular feeling in isolation.

Project 5
Full-on chandeliers

The idea of incorporating redundant or found objects within a design is an approach that has been explored for generations, and is gaining momentum with the drive for sustainable design. The malfunction of a single component within a product can result in complete rejection and the subsequent destruction of perfectly viable parts. Too much material is cast aside and forgotten prior to considering what it could be used for. A breakers' yard has a continuous supply of such discarded items, many of which are perfectly acceptable, but because there is damage to one element the whole thing is thrown out.

Collecting a range of white lamps from a breakers' yard, consider the various compositions that could be created in the generation of a chandelier. The lamps do not need to be from the same source, and the chandelier should have its own identity. Consider aspects that could be unique to the breakers' yard chandelier that would not normally be possible. Dipped lights or full beam?

Alternative chandeliers can be created through the use of indicator or rear lights and their different-coloured reflectors.

Project 6
Side step

Creativity should never be overlooked, irrespective of unfavourable conditions or situations. Constraints influence and perhaps curb directions but should also encourage lateral thinking, presenting opportunities rather than hindering. Good thinking does not require access to resources. Good thinking requires imagination, an ability to be resourceful, seek out opportunity and, where necessary, improvise. Those with no identifiable resources, even at a fundamental level, evidence some of the most creative outputs. Children or communities that have very basic tools embrace the problems presented by constraints and successfully overcome such barriers with designs that would never be considered by individuals with less imagination. A child can successfully transform a cardboard box into something that excites and entertains.

An imaginative craftsman can assemble a few innocuous items and generate something with meaning. The ability to see potential and not surrender to pressure is an important asset of the creative mind.

Consider the value, meaning and potential of a discarded tyre. What purposes could a tyre be used for that are remote from its former function. What are the qualities of a tyre that could be transposed to different products and how could the material be manipulated in an attempt to achieve such an outcome?

Can it be done?

Project 7
Target 100%

Using a standard, single sheet of particleboard, design an item of flat-pack furniture that has a sophisticated visual language. There are no restrictions on how the individual components are assembled, but the design should aim to generate zero waste without the overall aesthetic being compromised. Consideration needs to be given to how the shaped constituents are cut and removed without excessive spoilage of any virgin material.

Project 8
The collections

Polymer reference numbers appear on many plastic containers and provide information regarding the material that has been used in the formation of the product. Although the presence of a polymer reference number assists in identification it does not always correlate that the material can currently be recycled.

The different polymer reference numbers are identified within a triangle that can be found on the reverse of products.

Reference 1: PET (Polyethylene terephthalate)
Reference 2: HDPE (High Density Polyethylene)
Reference 3: PVC (Polyvinyl Chloride)
Reference 4: LDPE (Low Density Polyethylene)
Reference 5: PP (Polypropylene)
Reference 6: PS (Polystyrene)

Collect different plastic containers, with polymer reference numbers on, and sort into groups to ascertain an appreciation of the different material types and uses.

Project 9
Rebellion

The success of many design movements in the 20th century can be attributed to their questioning of convention and capacity to avoid predictable options. To shout in the face of unwritten rules and regulations, to take alternative pathways that cause consternation among those with a more conservative outlook, generates excitement and attention. However, in order to actively challenge contemporary thinking it is necessary to fully comprehend its meaning and values; to randomly explore alternatives without first understanding the status quo will cause confusion and a loss of identity.

There are numerous approaches to the process of design, and many interpretations. The role of the designer is to question, which means that generating a consensus of opinion among a group of designers is not always easy. However, there are some rudimentary ground rules to which most designers would probably subscribe.

Identify 10 fundamental ground rules associated to the discipline of product design and look to generate a series of products that ignores them.

Project 10
Trite and banal

Trite and banal products are also often referred to as being kitsch, items that appear to lack any self-respect and have been generated to amuse or pacify. These 'show-off' items are often a reflection of popular culture and are generally made from cheap plastics and incorporate garish colours and finishes. The lack of sophistication in these seemingly tacky objects is often part of their appeal and, although often dismissed as trinkets, they have also become sought-after items; fun reflections of particular periods in time.

It is a relatively simple task to identify kitsch items that were mass-produced during the expansion of the plastics industry during the 1950s and 1960s, with references being made to iconic figures and artificial symbols of prosperity.

Identify 50 products that could be considered to be contemporary kitsch or might eventually be assigned to that category.

Project 11
Just jargon

Designers are accustomed to venturing into the unknown and asking seemingly obvious questions. It is a routine task to gain a basic impression of something or to clarify a particular point. Without an intrepid attitude and an acceptance that sometimes things may not develop the way they were supposed to, ignorance may prevail and opportunities be missed. It is imperative to explore and to discuss, and when engagement does takes place it is often the case that the radically different is also very similar. Jargon can be a barrier, and if something is not understood it is not heard. There is seldom any support for the uninitiated or those who do not ask what unknown terms mean.

There are many examples of similar processes being utilised in different disciplines, but because they are known by different terms it can be difficult to identify such 'distant couples'. For example, rotational moulding and slip casting, or blow moulding and glass blowing, both have similar attributes, but are used differently. Identify as many 'distant couples' as possible that are separated by language.

Project 12
Cross-breeding

Cross-breeding unrelated elements to create something original, can result in some exciting proposals and opportunities being discovered.

Identify as many different materials and processes as possible and consider how each material could relate to every process. Aim to explore, as far as possible, the various options that are presented and how the findings could be used in the search for original products.

Project 13
Opposites attract

Project 14
Street performer

There are a huge range of historical references available for consultation through different cultural experiences, and by communicating with individuals who have experience of past or redundant practices. Methods of working particular materials, crafts that were abolished with the introduction of mechanisation, and specific techniques that passed through different generations can be sourced with some basic investigation. As the merger between mass-produced efficiency and one-off effectiveness becomes increasingly important, some of the outmoded techniques that languish in museums and historical centres simply require reworking and an opportunity to demonstrate their current potential. Contemporary exhibitions and museums are frequently attracted to items that appear to portray a labour-intensive, bespoke aesthetic, despite being removed from such intimate production methods.

Identify a series of traditional wood-working techniques where production has either declined or become extinct. Appreciate that the approach may have dwindled or faded because of production times rather than a decline in popularity and that the overall aesthetic could still be valued if made available. Consider contemporary production methods that might be capable of regenerating the lost aesthetic of an extinct practice. Proposals may need to adjust the aesthetic slightly for a contemporary audience, but should be representative of, if not faithful to, any historical references.

There are many types of street performers, yet whoever the artist and whatever their method of entertainment, their approaches normally mix ingenuity and raw improvisation.

Inspired by different street entertainers, and appreciating the narrative of their profession, create a collection of lights that capture the essence of a performance.

Can it be done?

Project 15
Personalising me

There is a burgeoning trend for individuals to incorporate their personal aesthetic into their possessions. Existing items such as clothing and furniture are often unofficially subjected to personal decoration and adaptation. Other products, such as personalised engraving on iPods, can cater for a personal aesthetic, but opportunities are still remain somewhat restricted.

The limitations for personalisation of objects and methods of production are being questioned. Why can't individuals be more involved in personalisation sooner, rather than waiting to modify something?

In many areas outside of design, items are purchased individually, according to personal preferences and tastes. The ingredients are there for the individual to play with and decide what works well.

Design a mobile phone that could be produced using a minimum number of essential components and allows for the consumer to complete the project according to their own preferences and desires. The approach and the subsequent skeletal design should aim to reduce as many unnecessary production processes as possible, creating increased flexibility and choice.

Project 16
Deckchair

The simple deckchair has been a familiar sight at seaside resorts for generations. Comprised of a few basic parts, the design is lightweight, colourful, and reliable. Using no further materials than those found in a deckchair, look to develop an alternative seaside seat, something that perhaps might be expected to appeal to a younger audience. As the completed design will use the same parts, the finished article should also be lightweight, must communicate a fun narrative, and be regarded as a development of an established idea.

Project 17
Freestyle lighting

A simple idea can often become overly complicated during its journey to production. If a simple idea cannot be harnessed through rigorous control then the initial appeal can be lost or forgotten.

Select any position within an identified space and aim to place a light bulb at the exact point. The light should only incorporate materials that are deemed to be easily accessible and no fixings can be used within the construction of the product. The completed item should be capable of being simply repaired or renovated by the target audience, while still retaining its simple aesthetic.

Project 18
Tea chest logistics

Using a standard-sized tea chest or removals container, design a collection of products that can be placed safely within the case and couriered to an identified exhibition venue. As the products will need to be relatively small to be enclosed in the container, consideration needs to be given to how they could adopt a particular presence at their selected destination.

The transportation of exhibitions, using various methods of transit, is complicated and expensive and therefore attention needs to be given to the weight and protection of the contents. In designing the products, aim to keep weight to a minimum without jeopardising the overall impact on arrival.

Although the box should not contribute to the components within, disassembly of the container may provide a suitable platform for the work to be presented on if carefully considered.

Consider the logistics of getting the tea chest collection to an identified destination and displayed.

Project 19
Paper table

Research different approaches to utility design
during the 1950s and consider the various
methods of construction and finish. Appreciate
the control of the work and the need to
manipulate material carefully and thoughtfully,
avoiding any waste or excesses.

Following on from the research stage, and
developing an understanding of necessary
discipline, design a simple table that can be
constructed using only paper or card. Having
completed a suitable design, aim to construct
an almost identical table using wood, and again
repeat the process using another material such
as metal or plastic.

Aim to make all the tables the same and
ensure that the weight of each table, including
the paper-based table, is identical. In order to
achieve the objective, some sacrifices will need
to be made and excessive material removed.

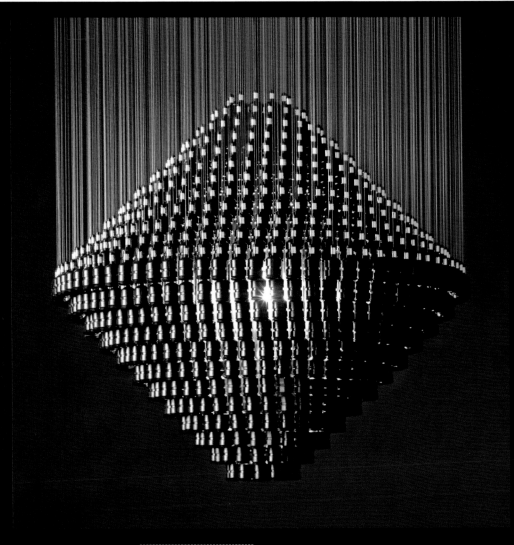

**Millennium Chandelier
(2004)**
The beautiful Millennium
Chandelier designed by
Stuart Haygarth manages
to successfully combine
old and new concepts at
multiple levels.

Design
Stuart Haygarth

Material thoughts

A desire to go beyond the familiar and explore the unusual reveals opportunities that may never have emerged without a sense of curiosity. It can be difficult to actively seek out the unfamiliar, and a structured exploration is perhaps less effective than simply absorbing everyday encounters and opportunities as they occur. A chance marriage of opposing ideas that catches an observer unaware can often be more stimulating and rewarding than a more traditional staged coupling of ideas. It is much better to discuss, question and experience things than to remain in isolation and not have an opportunity to invite suggestions or inspiration. What benefits are there to existing in a blinkered wilderness where nothing changes and nothing comes along to prompt direction?

The ever-growing abundance of emerging materials should be considered in conjunction with existing materials rather than be allowed to simply overshadow them. Young and original materials project energy and excite, but the maturity and wisdom of accustomed materials provides essential stability and balance within the creative arena.

Respect should be evenly distributed; innovative techniques to work materials should also be combined with traditional approaches. Methods of working are continually changing and developing and it is necessary to appreciate that possibilities can just as easily lead an individual astray as they can inspire; but there should be no rush to disregard ideas.

Conviction and belief are imperative and all ideas, young or old, which arrive unannounced should be welcomed; they are frequently the exciting visitors that shake everything up, entertain and introduce an alternative perspective.

Glossary

Abstract
An abstract thought is something that is perceived as being outside of normal thinking and manages to consider issues from an alternative or lateral perspective.

Ad-lib
Ad-lib refers to a spontaneous act without preparation or practice. An ad-lib may be an instant performance or development of an artefact. Something that is produced in an ad-lib fashion is immediate and responsive.

Aesthetics
Fundamental principles connected to emotional perceptions and understanding of beauty, judgement, and awareness.

Analogous
An analogy is when there is a resemblance or relationship between different things. An analogous product is when something seemingly unrelated has a comparable feature to that which is being considered.

Animate
Something that is described as having an animate trait means that it has a living characteristic, although this does not mean that it is physically alive.

Architectonic
Refers to a structure or form that has an aesthetically pleasing or poetic presence.

Art deco
Art deco was a design movement that emerged in the mid 1920s following the Exposition Internationale des Arts Décoratifs et Industriels Modernes 1925. The sophisticated and alluring style that embraced geometric patterns was adopted broadly until 1939.

Art nouveau
A decorative style in art and design that was prominent between the period 1890 to 1914. The distinctive elegant and graceful international style was evident in architecture, art, and design, and was seen to be a decorative response to the austere Industrial Revolution.

Banal
Something that may be regarded as being dull, boring or commonplace.

Baroque
A decorative and ornate period of art, architecture, and design in the mid 17th century.

Bauhaus
The Bauhaus was formed by architect Walter Gropius in 1919 and existed until 1933. The functional approach to design that the Bauhaus promoted had a significant impact on the development and understanding of art, architecture, craft and design. The Bauhaus set many of the foundations for the direction of design in the 20th century.

Cohort
A collection or group of individuals that share a similar characteristic.

Cross-pollinating
Cross pollinating, cross-breeding, or cross fertilisation within design refers to the sharing of ideas or resources from unfamiliar areas or disciplines in order to enhance experiences and knowledge.

Cullet
Broken glass that can be used in the glass-making process.

Ejector mark
Pins or bars are often used to eject a plastic product from a mould. Due to an item being susceptible to marking immediately after the forming process, the location where the ejectors hit is often visible by a small blemish.

Ergonomics
The study of suitability and efficiency of an individual or object in relationship to its surroundings.

Fabrication
The generation of a completed item from components that are preformed or prepared for assembly.

Facsimile
An identical copy of something.

Fibonacci
The Fibonacci sequence generates a spiral that is evident in many living forms. The sum of the previous two numbers is equal to the next number in the sequence.
1; 1; 2; 3; 5; 8; 13; 21; 34; 55; 89…

Flash
Flash is excess plastic that can sometimes be seen along the split line of a moulded product. Flash is created during the forming process when molten plastic is able to seep out of an old or poor mould. It is uncommon to see flash on most products.

Genre
Refers to a certain style or classification of something.

Grow
The term 'grow' or 'grown' is commonly used to refer to products that are or have been created using rapid prototyping.

Hackneyed
Something that has been utilised too often, is not original and does not excite.

Haute couture
Haute couture translates as 'high dressmaking'. This literal meaning clearly associates to fashion and the production of high-quality products by international fashion houses. However, the phrase is being increasingly used in other disciplines as a generic term for high quality.

Heterogeneous
Something that has a varied or an assorted character.

Hybrid
The result of combining separate and usually unrelated elements. The hybrid can be a combination of tangible or narrative characteristics.

Innovate
To generate an original idea, method or market that has not been previously evident, in contrast to a reconfiguration that does not break boundaries.

Jargon
Language and terminology that is used inside specific disciplines, or cultures, that can be awkward for outsiders to comprehend. Jargon specific to different groups can have completely different meanings and further complicates understanding.

Juxtaposition
The placing or bringing together of different elements.

Kerf
A kerf is the slot or slice made in a piece of wood by a saw. A piece of wood can have numerous kerfs to increase the flexibility of a material.

Kitsch
Cheap-looking products that are generally considered to be tacky, garish and without an appreciation of taste.

Lateral
Approaching or addressing something from the side or from a somewhat abstract perspective, rather than using the most obvious methods.

Literal
To contemplate or address something using the most obvious or fundamental form of approach is to take a literal view.

Macerate
The softening or reduction of a solid or semi-solid material using liquid.

Material library
Valuable sources of reference for understanding potential applications and properties. The international material libraries house an array of emerging materials from specialist producers.

Metamorphosis
The transformation from an identified state to a different and alternative state. The process is often related to the transition from the immature to the mature, but can also be applied to the transition of states of a similar status.

Mongrel
Term used to refer to an animate or inanimate being with mixed characteristics or traits that can be from an unspecified source.

Monochrome
Refers to the use of black and white or the use of various tones associated to a single colour.

Monomer
A molecule that can bond with identical molecules to form a polymer.

Morphology
The structure or form of an object.

Mutation
A genetic or specific change in makeup.

Narrative
The story that a product communicates through various means, including the statement associated to configuration and composition, the emotive language and historical references.

Omnipresent
Something that appears to be present everywhere, at every juncture. An omnipresent product is a familiar and common item.

One-off
Literally the production of one item that has a unique and distinct character. Product design frequently aims to embrace the one-off ideal with a mass-production approach. Although the term implies that only one is produced, occasionally the term is incorrectly used to mean low-batch production.

Open mind
An open-minded approach is one that is receptive to suggestions and prepared to consider unforeseen or previously unconsidered ideas. A liberal philosophy is reflective of an open mind.

Parison
A blob of glass or extruded plastic taken from the furnace that can be inflated to generate a desired form.

Polychrome
The use of different colours.

Polymer
A substance produced by the bonding of identical molecules or monomers.

Producers
The individuals or organisations that transfer an idea into a reality.

Self-fulfilling prophecy
The process of believing in something to an extent that it actually occurs or takes place, either by coincidence or through targeted strategies.

Semiology
The understanding of visual signs and symbols and their subsequent interpretation.

Sgraffito/Scraffito
The deliberate scratching of a surface to reveal an alternative or contrasting finish.

Split line
The split line on a product is evidence of where parts of the mould have come together to create the overall form. It is the area where the moulded components meet.

Sprue
A piece of plastic that is attached to an injection-moulded product after it has been formed. It is created at the point where the liquid plastic enters the mould and it is usually removed post production. The elimination of the sprue on a product leaves a small scar on the product surface, although this is often located in a remote region and not detrimental to the overall product.

Swatch
A small sample of something, often fabric or paper, which can be collected and tested or assessed prior to any further commitment.

Tangible
A physically existing item as apposed to an imaginary item or thought.

Trite
Something that has become too familiar and drab due to excessive exposure.

Visceral
Connecting with profound emotions and feeling rather than reason, judgement or comprehension.

Viscous
A substance that has a thick consistency, is usually sticky and is considered to be somewhere between an identifiable solid and a confirmed liquid.

Visual language
Refers to the visual impression or statement that a particular product communicates.

Running glossary definitions taken from the Concise Oxford English Dictionary.

Bibliography

Antonelli, P.
Mutant Materials in Contemporary Design
Museum of Modern Art (1995)

Bakker, G. and Ramekers, R.
Droog Design – Spirit of the Nineties
010 Uitgeverij (1998)

Bloemendaal, L.
Humanual
Uitgeverij BIS (Book Industry Services),
Amsterdam (2002)

Börnsen-Holtmann, N.
Italian Design
Benedikt Taschen (1994)

Bramston, D.
Basics Product Design: Idea Searching
AVA Publishing (2008)

Brownell, B.
Transmaterial
Princetown Architectural Press (2006)

Dempsey, A.
Styles, Schools and Movements
Thames & Hudson (2004)

De Noblet, J.
Industrial Design Reflection of a Century
Flammarion (1993)

Fiell, C. and Fiell, P.
Design for the 21st Century
Taschen (2003)

Forty, A.
Objects of Desire
Thames & Hudson (1986)

Fukasawa, N.
Naoto Fukasawa
Phaidon Press (2007)

Gabra-Liddell, M.
Alessi: The Design Factory
Academy Editions (1994)

Gamper, M.
100 Chairs in 100 Days and its 100 Ways
Dent-De-Leone (2007)

Gershenfeld, N.
When Things Start to Think
Hodder & Stoughton (1999)

Huntley, H.E.
**The Divine Proportion:
A Study in Mathematical Beauty**
Dover Publications, Inc., New York (1970)

Jensen, R.
The Dream Society
McGraw-Hill Education (1999)

Kaku, M.
Visions
Oxford University Press (1998)

Kelley, T.
The Ten Faces of Innovation
Doubleday Business (2005)

Lupton, E.
Skin
Laurence King Publishing (2002)

MacCarthy, F.
British Design Since 1880
Lund Humphries (1982)

Meneguzzo, M.
Philippe Starck Distordre
Electa/Alessi (1996)

Moors, A.
Simply Droog
Droog Design; Rev Ed edition (Jul 2006)

Myerson, J.
IDEO Masters of Innovation
Laurence King Publishing (2001)

Papanek, V.
The Green Imperative
Thames & Hudson (1995)

Pink, D.
A Whole New Mind
Cyan Books (2005)

Radice, B.
Ettore Sottsass: A Critical Biography
Thames & Hudson (1993)

Smith, P.
You Can Find Inspiration in Everything
Violette Editions (2001)

Sozzani, F.
Kartell
Skira Editore Milan (2003)

Sweet, F.
Frog: Form Follows Emotion
Thames & Hudson Ltd. (1999)

Thompson, D.
On Growth and Form
Cambridge University Press (1961)

Various
**And Fork: 100 Designers, 10 Curators,
10 Good Designs**
Phaidon Press Ltd. (2007)

Walker, S.
**Sustainable by Design –
Explorations In Theory and Practice**
Earthscan Ltd. (2006)

Websites

www.basell.com
www.bayermaterialscience.com
www.cooperhewitt.org
www.core77.com
www.cosmit.it
www.csd.org.uk
www.designboom.com
www.designmuseum.org
www.designspotter.com
www.dupont.com
www.idsa.com
www.iom3.org
www.materialconnexion.com
www.moma.org
www.newdesigners.com
www.nhm.ac.uk
www.polymerlibrary.com
www.thersa.org.uk
www.sabic.com
www.sciencemuseum.com
www.tate.org.uk
www.ted.com
www.vam.ac.uk

Journals and magazines

Abitare
Artform
AZURE
Blueprint
b0x
Business Week
DEdiCate
Design
Design Week
dwell
domus
Egg
FRAME
frieze
FRUiTS
icon
I.D.
INNOVATION
Intramuros
Kult
Lowdown
made
Materials world
MARK
Metropolis magazine
mix
MODO
MONUMENT
newdesign
NewScientist
Product Design WORLD
Science magazine
surface
Stuff
T3
TWILL
vanidad
wallpaper
W magazine

Contacts

www.barnabybarford.co.uk
www.bengtssondesign.com
www.chriskabel.com
www.demakersvan.com
www.dominicwilcox.com
www.droogdesign.com
www.ecal.ch
www.edra.com
www.fabricanltd.com
www.freedomofcreation.com
www.frontdesign.se
www.futurefactories.com
www.gampermartino.com
www.genekiegel.co.uk
www.gufram.com
www.hayonstudio.com
www.helenamymurray.com
www.ideo.com
www.imagination.lancaster.ac.uk
www.industreal.it
www.ingo-maurer.com
www.jonassamson.com
www.jurgenbey.nl
www.kartell.it
www.lincoln.ac.uk
www.maartenbaas.com
www.materialise.com
www.matthias-studio.com
www.memphis-milano.it
www.molodesign.com
www.moooi.com
www.nikazupanc.com
www.os00.com
www.paulloebach.com
www.remyveenhuizen.nl
www.sandrabacklund.com
www.simonheijdens.com
www.stuarthaygarth.com
www.studiobramston.com
www.studiolibertiny.com
www.thorstenvanelten.com
www.tokujin.com
www.wiekisomers.com
www.wisdesign.se
www.zanotta.it

Thank you to all the designers, artists, makers, producers, photographers and researchers who have supported this project and provided exciting images and statements. The project aimed to bring together a broad array of disciplines to inspire thinking in the area of product design and without the support of the creative community it would not have been possible. The information has been sourced from all over the world and has involved the wonderful outputs of young and experienced individuals and organisations. The involvement of all of these individuals is very much appreciated.

Many thanks also to the Lincoln School of Art & Design, at the University of Lincoln (UK) and in particular the staff and students of the Product Design programme.

Thank you to John Mulhall, also at the University of Lincoln, for specialist input, and to Malcolm Southward for the book design.

Finally it is important to recognise and thank the incredible staff at AVA publishing and in particular Georgia Kennedy, Caroline Walmsley, Lucy Tipton, and Brian Morris, who identified the project and provided the opportunity, support and drive for the book.

Lynne Elvins
Naomi Goulder

BASICS
PRODUCT DESIGN

Working with ethics

Publisher's note

The subject of ethics is not new, yet its consideration within the applied visual arts is perhaps not as prevalent as it might be. Our aim here is to help a new generation of students, educators and practitioners find a methodology for structuring their thoughts and reflections in this vital area.

AVA Publishing hopes that these **Working with ethics** pages provide a platform for consideration and a flexible method for incorporating ethical concerns in the work of educators, students and professionals. Our approach consists of four parts:

The **introduction** is intended to be an accessible snapshot of the ethical landscape, both in terms of historical development and current dominant themes.

The **framework** positions ethical consideration into four areas and poses questions about the practical implications that might occur. Marking your response to each of these questions on the scale shown will allow your reactions to be further explored by comparison.

The **case study** sets out a real project and then poses some ethical questions for further consideration. This is a focus point for a debate rather than a critical analysis so there are no predetermined right or wrong answers.

A selection of **further reading** for you to consider areas of particular interest in more detail.

Working with ethics

Introduction

Ethics is a complex subject that interlaces the idea of responsibilities to society with a wide range of considerations relevant to the character and happiness of the individual. It concerns virtues of compassion, loyalty and strength, but also of confidence, imagination, humour and optimism. As introduced in ancient Greek philosophy, the fundamental ethical question is *what should I do?* How we might pursue a 'good' life not only raises moral concerns about the effects of our actions on others, but also personal concerns about our own integrity.

In modern times the most important and controversial questions in ethics have been the moral ones. With growing populations and improvements in mobility and communications, it is not surprising that considerations about how to structure our lives together on the planet should come to the forefront. For visual artists and communicators it should be no surprise that these considerations will enter into the creative process.

Some ethical considerations are already enshrined in government laws and regulations or in professional codes of conduct. For example, plagiarism and breaches of confidentiality can be punishable offences. Legislation in various nations makes it unlawful to exclude people with disabilities from accessing information or spaces. The trade of ivory as a material has been banned in many countries. In these cases, a clear line has been drawn under what is unacceptable.

But most ethical matters remain open to debate, among experts and lay-people alike, and in the end we have to make our own choices on the basis of our own guiding principles or values. Is it more ethical to work for a charity than for a commercial company? Is it unethical to create something that others find ugly or offensive?

Specific questions such as these may lead to other questions that are more abstract. For example, is it only effects on humans (and what they care about) that are important, or might effects on the natural world require attention too?

Is promoting ethical consequences justified even when it requires ethical sacrifices along the way? Must there be a single unifying theory of ethics (such as the Utilitarian thesis that the right course of action is always the one that leads to the greatest happiness of the greatest number), or might there always be many different ethical values that pull a person in various directions?

As we enter into ethical debate and engage with these dilemmas on a personal and professional level, we may change our views or change our view of others. The real test though is whether, as we reflect on these matters, we change the way we act as well as the way we think. Socrates, the 'father' of philosophy, proposed that people will naturally do 'good' if they know what is right. But this point might only lead us to yet another question: *how do we know what is right?*

Working with ethics

You
What are your ethical beliefs?

Central to everything you do will be your attitude to people and issues around you. For some people their ethics are an active part of the decisions they make everyday as a consumer, a voter or a working professional. Others may think about ethics very little and yet this does not automatically make them unethical. Personal beliefs, lifestyle, politics, nationality, religion, gender, class or education can all influence your ethical viewpoint.

Using the scale, where would you place yourself? What do you take into account to make your decision? Compare results with your friends or colleagues.

Your client
What are your terms?

Working relationships are central to whether ethics can be embedded into a project and your conduct on a day-to-day basis is a demonstration of your professional ethics. The decision with the biggest impact is whom you choose to work with in the first place. Cigarette companies or arms traders are often-cited examples when talking about where a line might be drawn, but rarely are real situations so extreme. At what point might you turn down a project on ethical grounds and how much does the reality of having to earn a living affect your ability to choose?

Using the scale, where would you place a project? How does this compare to your personal ethical level?

01 02 03 04 05 06 07 08 09 10

01 02 03 04 05 06 07 08 09 10

Your specifications
What are the impacts of your materials?

In relatively recent times we are learning that many natural materials are in short supply. At the same time we are increasingly aware that some man-made materials can have harmful, long-term effects on people or the planet. How much do you know about the materials that you use? Do you know where they come from, how far they travel and under what conditions they are obtained? When your creation is no longer needed, will it be easy and safe to recycle? Will it disappear without a trace? Are these considerations your responsibility or are they out of your hands?

Using the scale, mark how ethical your material choices are.

Your creation
What is the purpose of your work?

Between you, your colleagues and an agreed brief, what will your creation achieve? What purpose will it have in society and will it make a positive contribution? Should your work result in more than commercial success or industry awards? Might your creation help save lives, educate, protect or inspire? Form and function are two established ways of judging a creation, but there is little consensus on the obligations of visual artists and communicators towards society, or the role they might have in solving social or environmental problems. If you want recognition for being the creator, how responsible are you for what you create and where might that responsibility end?

Using the scale, mark how ethical the purpose of your work is.

01 02 03 04 05 06 07 08 09 10

01 02 03 04 05 06 07 08 09 10

Working with ethics

One aspect of product design that raises an ethical dilemma is the environmental impact that materials can have. This issue needs more consideration, particularly if an object is knowingly designed to become waste after only a short time. The advent of synthetic plastics in the early 20th century opened the door to mass production of cheap, attractive goods that democratised the ownership of consumer products.

Planned obsolescence became a lucrative strategy for large companies in the 1950s and this fuelled ongoing product replacements through styling changes. But as the longer-term impacts of man-made plastics became more widely understood in the second half of the 20th century, it has become clear that there is an environmental price to pay for human convenience and consumer choice. How much responsibility should a product designer have in this situation? If designers wish to minimise the environmental impacts of products, what might they most usefully do?

Newspaper editor László Bíró (1899-1985), found that he wasted a great deal of time filling his pen with ink, cleaning up smudges and tearing pages with the nib of his fountain pen. With help from his brother, Bíró began to work on a new type of pen and fitted a tiny ball in its tip that was free to turn in a socket. He filed a British patent for the design in June 1938.

In 1945, Marcel Bich, along with his partner Edouard Buffard, bought a factory in France and went into business as the maker of parts for fountain pens and mechanical lead pencils. As his business began to grow, the development of the ballpoint pen was advancing in both Europe and the US. Bich saw the great potential for this new writing instrument and obtained the patent rights from Bíró to manufacture his own. In 1950, Bich launched his new reliable pen at an affordable price. He called it BIC (the 'h' from Bich was dropped in order to avoid the English pronunciation 'bitch').

The BIC biro was a mass-produced consumer item that was cheap enough that if it were accidentally lost, the owner would be unlikely to care. Its mass success comes out of the BIC product philosophy: 'just what is necessary', a phrase driven by simplicity, functionality, quality and price. The aim is for harmony between the form of a product and the use it is designed for.

A BIC pen can draw a line up to three kilometres long. It is made from polystyrene (transparent barrel), polypropylene (cap), tungsten carbide (ball) and brass/nickel silver (tip). The environmental impact of a BIC biro comes predominantly from the materials, with approximately five grammes of oil-based plastic used in the manufacture of each pen. Because of their widespread use by schoolchildren, all ballpoint ink formulas are non-toxic and the manufacturing and content of ink is regulated in most countries.

The relatively recent addition of the vent hole in the cap of the BIC pen was designed to minimise the risk of choking should it be swallowed. This is a requirement to comply with international safety standards after an incident in the late 1980s where a young child in the UK died due to the inhalation of a pen cap. Nine similar deaths had been recorded in the previous 15 years, none has been recorded in the UK since the publication of this safety standard.

The BIC biro has become an industrial design classic. In 2002 it entered the permanent collections of the Museum of Modern Art (MOMA) in New York. In September 2005, BIC sold its one hundred billionth disposable ballpoint, making it the world's best-selling pen.

Should designers, producers or users have responsibility if a product causes injury?

Is it unethical to design a product to be thrown away?

Would you have worked on this project?

Our definitions of positive impact have become too narrow as designers. Focused perhaps too often on pleasing our own ego.

Tim Brown
(CEO of IDEO)
From a transcription of a presentation given at the *InterSections* conference in 2007

Working with ethics

Further reading

AIGA
Design business and ethics
2007, AIGA

Eaton, Marcia Muelder
Aesthetics and the good life
1989, Associated University Press

Ellison, David
Ethics and aesthetics in European modernist literature
2001, Cambridge University Press

Fenner, David EW (Ed.)
Ethics and the arts: an anthology
1995, Garland Reference Library of Social Science

Gini, Al (Ed.)
Case studies in business ethics
2005, Prentice Hall

McDonough, William and Braungart, Michael
Cradle to Cradle: Remaking the Way We Make Things
2002, North Point Press

Papanek, Victor
Design for the Real World: Human Ecology and Social Change
1985, Academy Chicago Publishers

United Nations
Global Compact: The Ten Principles
www.unglobalcompact.org/AboutTheGC/TheTenPrinciples/index.html